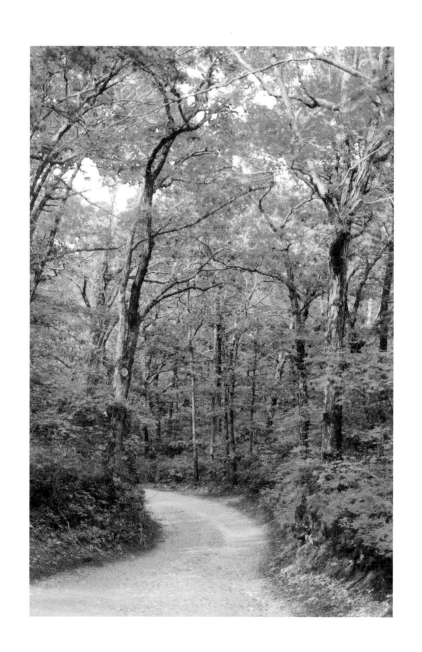

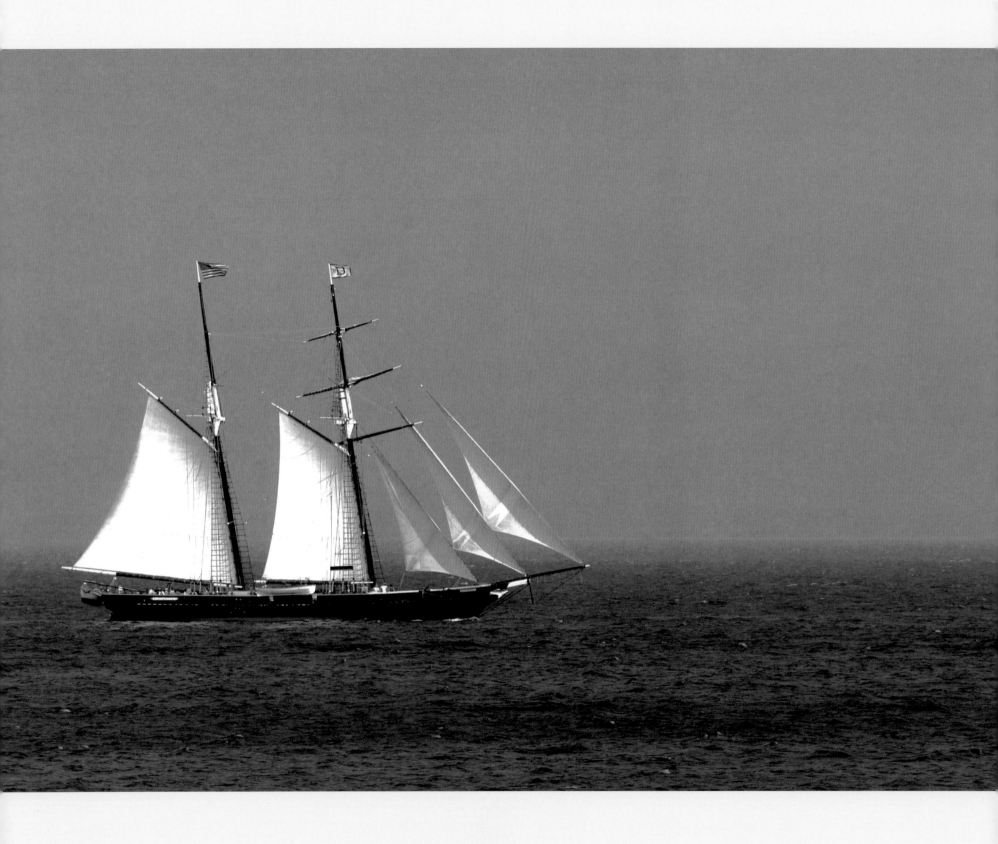

VINEYARD DAYS, VINEYARD NIGHTS

THE ROMANCE OF MARTHA'S VINEYARD

NANCY ELLISON

WITH AN ESSAY BY PAUL THEROUX

Stewart, Tabori & Chang
New York

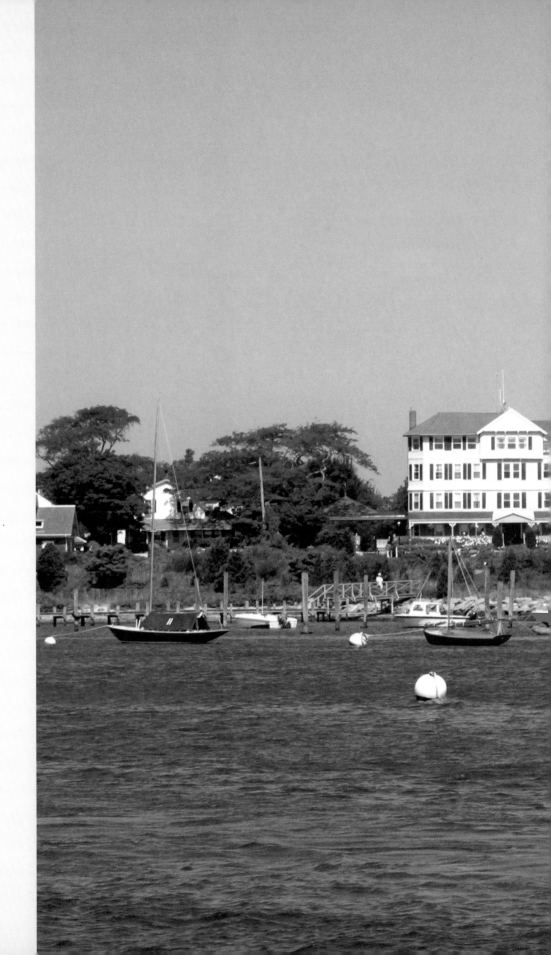

To my love, Bill, my stalwart assistant, advisor, and director . . . but mostly the best friend I've ever had.

To our dear friend Paul Theroux.

And to the year-round residents of Martha's Vineyard–whose collective integrity has given our beautiful Island its soul.

Edgartown Harbor

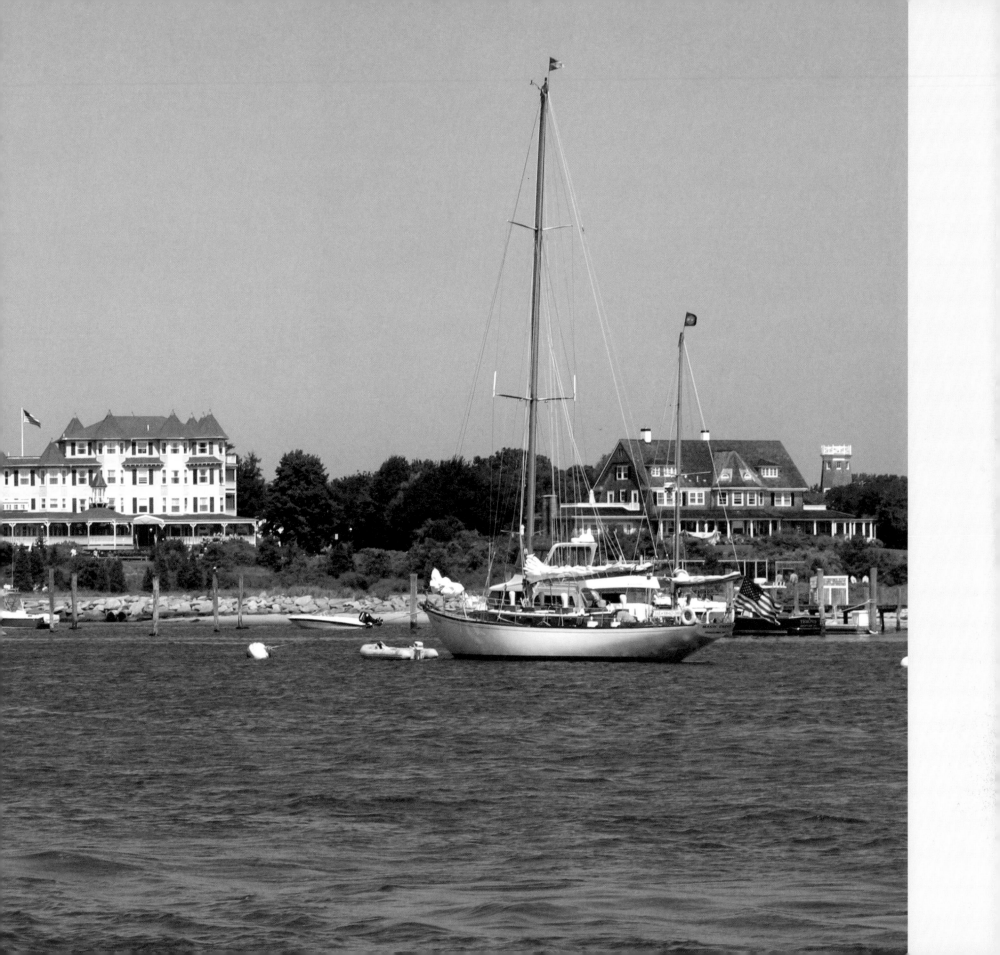

CONTENTS

It's a chilly November day in New York, and I've just gotten our weekly *Vineyard Gazette* in the mail. In a banner running across the top, there is a timely quote from John Masefield: "The beechwood grey rose dim in the night With moonlight fallen in pools of light, The long dead leaves on the ground were rimed . . ."

Under its masthead are the familiar statistics and mission statement: "Island of Martha's Vineyard, seven miles off southeast coast of Massachusetts. Winter population 15,007; in summer, 105,624. Twenty miles from city of New Bedford, 80 miles from Boston and 150 miles from New York. Devoted to [not dedicated to but devoted to] the interests of the six towns on the Island of Martha's Vineyard . . . "

This lovely old-fashioned newspaper, unlike any I've ever read, offers such above-the-crease headlines as "In Historic First, Vineyard Boys Reach Soccer Championship; Game Tomorrow" and "Superior Court Judge Will Not Revisit Ruling On Sovereignty of Tribe," but it is the story on page three that attracts my attention: "Wreckage of Rare Six-Masted Schooner Discovered by High-Tech Salvage Team." Six masts. Largest sailing vessel ever. Wrecked in 1924 in Island waters. One of nearly a thousand ships lost in waters surrounding the Island. Split in half by a gale! There are even photographs taken back then—a wondrous ship, 330 feet long and 50 feet across the beam. It reminds me of all the beautiful, but smaller, schooners that still sail the waters off the Vineyard. Oh, how I miss that lovely island!

I think of the rare Thanksgiving and Christmas holidays my husband and I enjoyed on-Island: The truly fresh air and remarkably starry nights—and an equally rare opportunity to live as Islanders do off-season.

Our "in residence," if we are lucky, begins some time in May, when Martha's Vineyard is still very much in spring: The Island is delicate, rainy, moody at times, but it is a time when the Islanders and Vineyarders greet the few summer residents who come to open their homes in May cordially, with optimism. Shops and restaurants are also opening their doors. "Blues" are being caught offshore, and there is a quiet uncrowded gaiety—much like the first sips of champagne. Everyone is happy to be on-Island. City folk who pal around off-season greet each other as if it's been years. The first sip of champagne, the first lady's slippers, the first gift opened at a birthday party! A time when sunlight promises the summer to come and nightfall allows for a roaring fire and good book . . .

June is delicious even if the weather can be unpredictable, larkspur are in bloom, the "stripers" are running, there is always a table available at your favorite restaurant. The roads are only beginning to show traffic ("rush minute"). And the Farmers' Market opens with a perky, spacious ambience. This outdoor gathering (held Saturday mornings and Wednesday afternoons at the Old Ag (Agriculture Hall), offers produce and crafts from the Vineyard exclusively—handspun and hand-dyed wool from the famous Island sheep, marbleized paper made from such natural fibers as seaweed and corn husks, sauces and jams, bakery products, and of course, farm-grown fruits and vegetables. Early summer brings baby potatoes (red, white, and blue, which make Fourth of July parties especially festive), carrots, lettuces of all kinds, onions, fiddlehead ferns, and for a few precious weeks, Morning Glory Farm strawberries—the sweetest strawberries I've ever had. They are gone by early July; so for that brief season we virtually survive on strawberries alone. And then there are the Island-grown flowers—arranged not by type but gathered loosely in random arrangements and stored in coffee cans. Changing with the summer season, the arrangements start out with the pale blues and pinks of early summer and end with the reds and yellows of August.

During May and June the Island carries on its real life as if we summer people were bystanders—children come and go to school, seniors graduate, lovers marry. The papers are filled with images that mark transitions: normal life in other words. But by July, life begins to be about summer people: the residents who own summer homes, the renters, the houseguests, and the daytrippers. The economy of the Island is now measured by bicycle rentals, boat charters, and dinners served. Those clubs dormant the rest of the year reopen, sailboats fill the sounds and harbors, beaches fill with

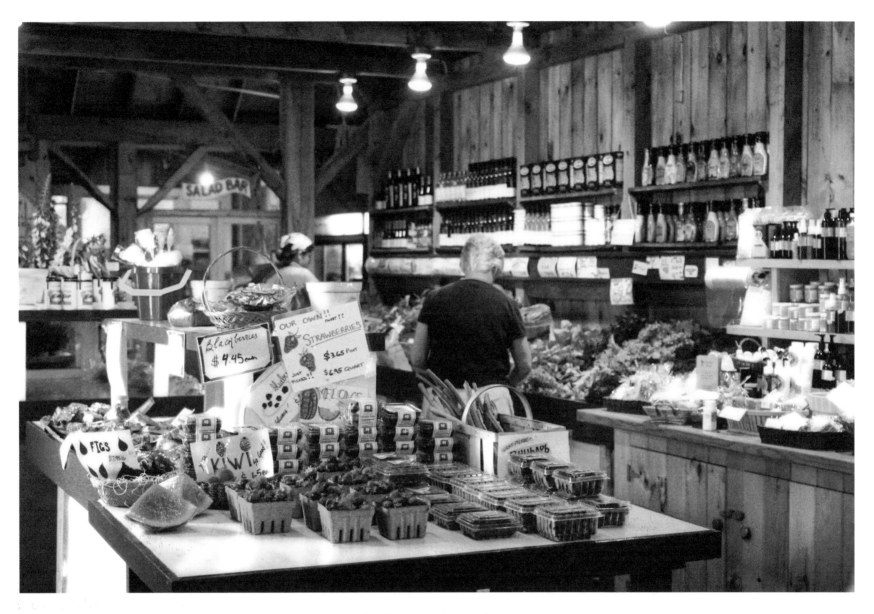

Morning Glory Farm Market, Edgartown

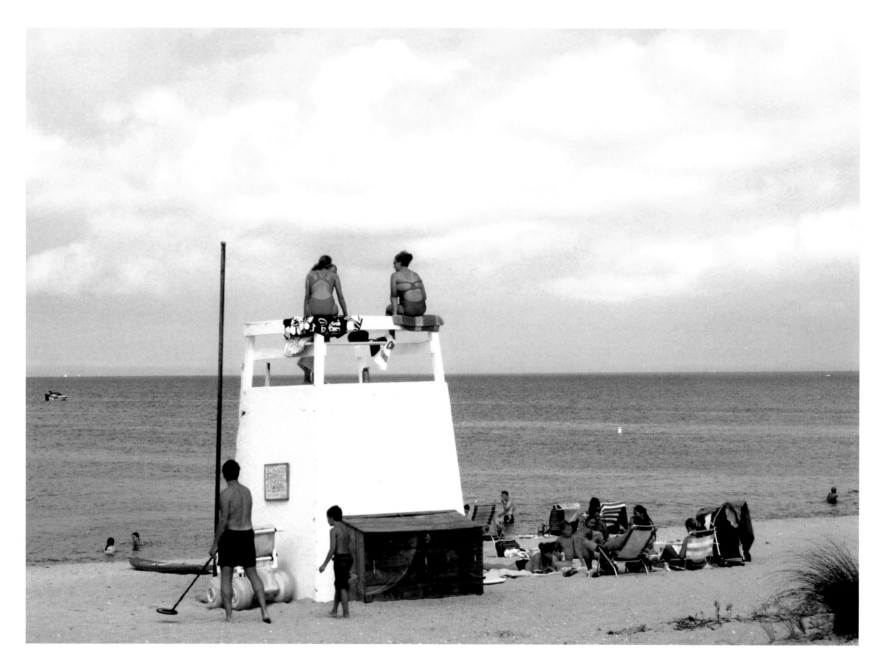

State Beach, Oak Bluffs

sunbathers. Most of the beaches have residence parking restrictions in the summer, but according to Massachusetts law if you walk onto a beach with a fishing pole you can go anywhere. Bunch of Grapes and Edgartown Books begin their season of book parties, plays open, concerts are held, and people plan dinner parties. Friends who have rented homes in both July and August define the difference between these two months as July being quieter, more family-oriented, while August is the scene—the big parties, the high-profile visitors.

August, relatively speaking, is the crush of summer. It is hot, sometimes wildly humid, and traffic goes from rush minute to rush minutes. Restaurants are booked in advance and, except for the bonito and albies, most of the fish have headed out to cooler waters. August, especially early August, provides its greatest challenge to the usual tranquility of the Island. New arrivals, after a hot July in the city, bring with them to the Island an impatience that the rest of us "mellow fellows" find barely amusing. Last year, for instance, a horse got loose on the Allen Sheep Farm blocking traffic in Chilmark. Motorists patiently stopped until the horse could be retrieved, except one newcomer who broke line, cursed, and honked at the frightened animal as he swerved around it. I have also heard of "corn fights" at the Morning Glory Farm Market. The sweet New England white corn is picked early each morning and brought into the store around nine. There is only so much for the day. I confronted an employee of the market about the situation, picturing Edgartown ladies in tennis whites pulling each other's hair out for the last few ears. I was told diplomatically "that while the corn is indeed 'fresh,' it seldom fights among itself."

By the end of August, the city renters have been tranquilized by the beauty of the Island and it is the year-round residents who are beginning to show signs of stress. "Summer people . . . and some are not!"

But September! Ah, September—most all the summer folk have packed up and left—and September becomes the real summer month, the Islanders' summer. The best month of the year. The Martha's Vineyard Striped Bass and Bluefish Derby begins, the humidity drops, the waters are warm, the air clear and sunny, restaurants are still open and accessible. Life is truly perfect. If we are lucky enough to be there in September, we feel most like Islanders ourselves. It is a privilege, though I know we'll be off-Island soon enough.

I have used the terms 'Vineyarders' and 'Islanders' interchangeably yet there seems to be a distinction. A Vineyarder is someone who lives on Martha's Vineyard. An Islander on the other hand is someone whose family was born on the Island. Whether Islander, Vineyarder, summer resident, or casual visitor, anyone who experiences the Vineyard will understand our love for the Island and our utter respect and appreciation for its year-round community.

The year-round residents of Martha's Vineyard keep the outside world from intruding upon its shores. They are a community that puts conservation above progress, a community that has always been diverse, and one that, as small as it is, supports its artists and writers . . . in short, a very human and humane paradise.

Prince Andrew, a recent visitor to the Island, was trying to grasp the magic of the Vineyard and the fact that its many wealthy and sometimes famous residents and visitors live simply and unpretentiously, unlike residents of other summer resorts. After much discussion he brightened: "Ah," he said, "like Scotland!" Perhaps, but mostly it's just like Martha's Vineyard.

NANCY ELLISON

MARTHA'S VINEYARD

The small porch of a simple, soulful white frame house set back like a pretty wooden pavilion from the shore sums up the Vineyard I know best. You have to begin somewhere, and on an island the ideal entry point is a hospitable place on the coast. This porch on the northwest side of the busy harbor at Vineyard Haven is itself a haven.

I also know the inland meadows and woods, the cliffs, the marshes, the beaches, the harbors. I have sailed my boat entirely around the Island; I have kayaked across the Sound to and from the Cape, alone, many times; even rowed my dory there. Those are summer trips. In other months I have pedaled my bike from Oak Bluffs to Gay Head and from Lambert's Cove to Chappaquiddick, on the empty winter roads and past the daffodils that bloom in April all over the Island. As a neighbor and a visitor rather than a resident, I recognize no boundaries on the Vineyard. I have also camped illegally on the beaches, notably at Katama, waking up soaked with dew, a lovely memory made even sweeter by the thought that I was trespassing.

One of my first summer jobs as a mainland boy and a college student in the early 1960s was washing dishes at a large hotel in Vineyard Haven. The place was owned by a sententious and cynical crook from the Irish mob in Boston, long dead, unmourned. Squinting through thick-lensed glasses he taught me the theory and practice of defrauding banks by illegally "kiting" checks and told me that if my timing was right and I had five bank accounts I would never need money. I humored him in his bad temper because I was somewhat afraid of his aggression and hated the tedious job: nowhere to read a book in my spare time, and the only free bunk was under the squeaky tramped-on stairs that led from the kitchen. I lasted about a week. One day I mounted my motor-bike and fled to the ferry ramp and was gone without a goodbye. God bless islands for being like great anchored vessels, and for the way that leaving them suggests all the ambiguity of jumping ship. The Vineyard is like the largest ship of the line, a world unto itself, full of marvels, full of life, as on that particular porch.

The white frame house is surrounded by trees and in summer blue hydrangeas, trumpet vines, and like most coastal plots on the Vineyard, thick blowing *Rosa rugosa*. The fragrance of the flowers is part of the serenity of this house. Even when the skunks and woodchucks are doing their worst the lawn is rug-like and lush. The porch is bordered by window boxes and a hedge where it faces the protected harbor and bobbing boats and, far-off, beyond the Sound, Cape Cod, no more than a gray stripe you might mistake for a low cloud.

The enclosed space of this porch is hardly more than twenty feet long and seven feet wide. A dozen or so people can be accommodated on it–not more. The furniture is unremarkable–a wicker sofa and some folding chairs, a couple of armchairs, a rocking chair, all of these chosen for comfort rather than style. You can prop yourself on the rail or sit on the steps that lead to the lawn. Beyond the lawn and seawall is a narrow weathered dock and even in the distance at night a winking green light showing the channel; but even so you would never mistake this house or this porch for Gatsby's.

This is the Styrons' porch–Bill is in the rocker, Rose is passing through with her tennis racket, children's voices in the distance–and for all the life I have seen there, it seems to me the best of the Vineyard.

I feel the whole world has passed along this porch, which is a perennial destination for droppers-in and handymen and fishermen, politicians, journalists, university professors, Nobel laureates, poets, musicians, movie directors, the Styrons' children and young grandchildren, their adored cook Daphne, and any number of friendly dogs. The president of the United States sat on the porch and wolfed down Daphne's fried chicken; several first ladies sipped tea there, including Lady Bird Johnson who for years spent summers just next door. Lillian Hellman, David McCullough, Walter and Betsy Cronkite, Mike and Mary Wallace, Jules Feiffer, the Vernon Jordans, the Arthur Schlesingers, Bill and Nancy Rollnick, Skip Gates, Art Buchwald–all of them more or less from up the road, Mike Nichols

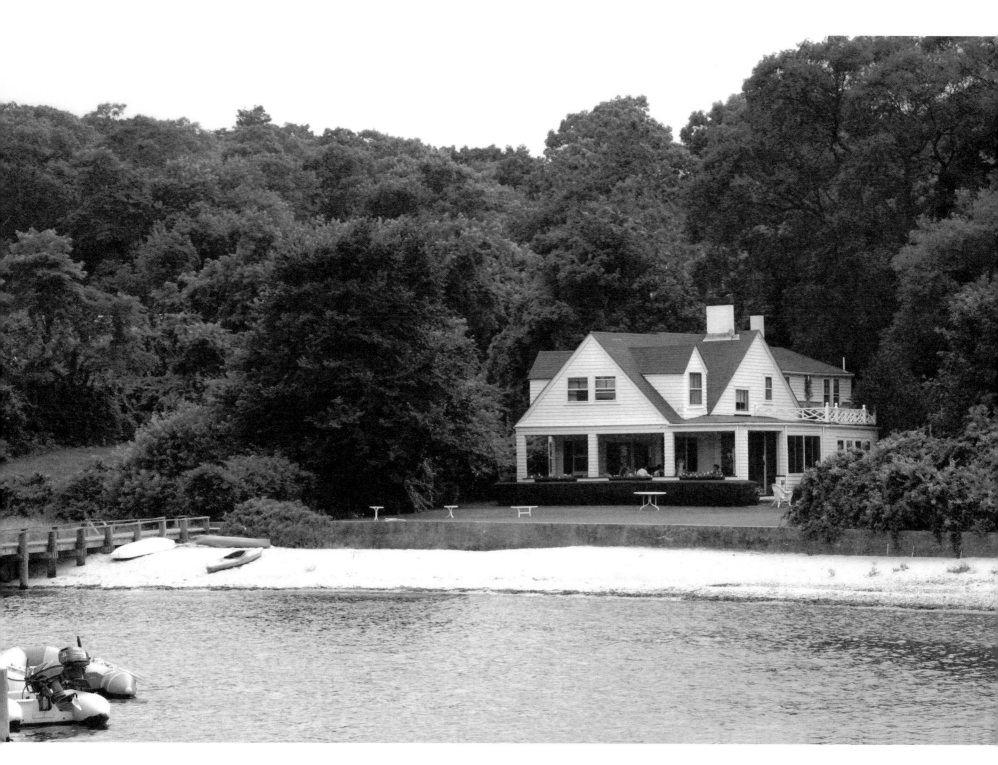

Back porch, Vineyard Haven Harbor

and Diane Sawyer from their villa behind a coastal dune, Spike Lee in from Oak Bluffs; many others. One day, Teddy Kennedy anchored offshore to hand-deliver a picture of a sailboat he had painted. The porch is a meeting point for Rose's tennis partners–Katharine Graham was once one of them. "But I had hip surgery," she said, when she was nearly 80, "and I don't know how much longer I'll be able to play."

To go to an island for fresh air and friendship is one thing; but how amazing to find that it is populated with individuals of accomplishment–good people who have done great things. Out of the hundreds, perhaps thousands, of residents and visitors who have sat on Styron's porch I have never seen anyone do business there, never saw anyone make a deal, or execute a contract, nor talk about golf, nor in an acquisitive sense discuss money. But I have heard many people on Styron's porch talk about human rights, and quote Shakespeare and William Faulkner; and the United States president quoted Styron himself, an eloquent passage from *The Confessions of Nat Turner*.

When it is empty the porch casts a spell. Facing east, it is beautifully protected, in the lee of the summer wind, with a lovely view of East Chop, always glowing in the sunset. The topsail schooner *Shenandoah*, the trophy yachts and the little boats all sail past, going in and out of the harbor. So do the ferries and the fishing boats. About ten years ago, the *Queen Elizabeth II* anchored in view of the porch, off East Chop, the day before she hit a rock in Vineyard Sound and had to be evacuated and towed to a shipyard. The ordinariness of the porch's setting is part of the pleasure, and the way it gives a human scale to the famous and the familiar seems to me part of the Vineyard transformation.

Everything on this island seems unfaked, existing as a graspable size and resisting the worst of modernities, blights, and vulgarities. The preservationists are fighting a rear-guard action against the vulgarians but so far there have been more victories than defeats–not a tall building or a fast-food franchise in the whole place. Imagine a summer population in excess of 100,000, residents and visitors, and all that prosperity, and not a McDonald's nor a Burger King nor a Taco Bell to be seen. No Wal-Mart, just local shops; no multiplex cinemas, just modest movie houses. An island of independent

bookstores, no bookstore chains, no chains at all. Their absence is unlamented by the majority of Islanders. Although there are no traffic lights on the Island—image that—there are plenty of markers and blinking cans and buoys offshore and at harbor entrances, and a number of bell buoys that warn boaters with solemn gongs.

Approaching the Vineyard from the Cape by water–which is the only way to understand this island–and looking across Nantucket Sound from the Falmouth side, the two most visible landmarks on a good day are the light houses, East Chop and West Chop. Each stands like a giant salt shaker on its own bluff, marking either side of the entrance to Vineyard Haven. You might think that "chop" refers to the water below these lights, because on an ebb tide they are turbulent with a strong choppy current and standing waves. But no, these chops are the parted jaws of the opening to the harbor, and this old name has stuck, the same word as in the expression licking your chops, something a nor'easter does to these cliffs. A lot of the land features have a Shakespearean euphony, and even the local accent has been described as originating in England, the Yankee twang, of eastern Massachusetts, this "high pitched nasality" being an extension of what philologists call "the Norfolk whine."

Even on the most peaceful-seeming day in summer, the Vineyard a jewel across the lovely Sound, the sea flashing and glittering, smacked by the prevailing breeze from the south-west–even in all that serenity, the waters around the Island are so dangerous that the most familiar boaters are the most respectful. Because of its treacherous waters the Vineyard is much more isolated than its proximity to the Cape would suggest. Nantucket Sound and Vineyard Sound are notorious ship swallowers and many vessels heading to the Vineyard have foundered on the Cape's beaches or been torn apart in the channels. Because of the shoals and the tides and the inconsistent winds, even the shortest distance, Nobska on the Cape to Tashmoo on the Vineyard, no more than four miles, is such a challenge for a small sailboat or a sea-kayaker that on many days the trip is impossible.

On this enduring island, the past exists in the present. The surrounding sea that is such a challenge continues to be the Vineyard's protection. Such was the case from the very beginning of foreign

exploration. Long after other places on the New England coast were settled, the Vineyard remained unvisited by outsiders. Until 1600 an estimated 400 European ships explored or fished along this coast. Only one of these vessels attempted a description of Cape Cod and the islands—the *Dauphine* under the command of Giovanni da Verrazzano in 1524, who was the first to recognize the continuity of the North American coast.

The reason for the other ships giving this part of the coast a wide berth is clear enough: Cape Cod may be grandly characterized as a terminal moraine but that is merely an orotund vagueness for suggesting that it is a mammoth sand spit with hard-to-enter harbors on its bay side and rocky shoals on its Atlantic shore, barriers to approaching the islands of Nantucket and Martha's Vineyard. The harbor bars, sudden sandbanks, the rocky shoals, the surging tides, and the eccentric weather all combine to make this area "one of the most dangerous spots on the Atlantic coast," according to the biographer (W. F. Gookin, a Vineyard man) of Bartholomew Gosnold. Gosnold sailed from Cornwall in the Concord and ventured just off Cape Cod in the spring of 1602. The early explorers and coasters before him were so wary of foundering or beaching themselves they detoured around this area without coming near enough to see it clearly, much less go ashore. But Gosnold scrambled onto the Cape on the bay side and hiked with his men to a hill on the high spine of the peninsula where he got a view of the islands to the south.

Gosnold was not intimidated by the shipping hazards. He was deliberately headed here. It is fairly certain that he was looking for gold. The assumption was that gold could be had on this coast, for after all, a great deal had been found by the Spanish in this hemisphere. The thinking was that the Indians knew where the gold was. Coasting for about a month, rounding the Cape and Nantucket, anchoring off the Vineyard, entering Buzzard's Bay, making camp on *Cuttyhunk,* Gosnold and his mates gave names to every significant landmark and island he saw. Some of those names stuck —Martha's Vineyard named after Gosnold's daughter, and the Elizabeth Islands after the queen.

Gosnold's patron was the Henry Wriothesley, the third Earl of Southampton—who wanted the gold. It has been conjectured that a narrative of the voyage, written by one of the crew, John Brereton, was studied by Shakespeare and portions of it used in *The Tempest,* for the Earl of Southampton was also a patron of Shakespeare, who dedicated his only two published poems to him. Though Shakespeare's imagination was fired by a shipwreck off Bermuda, he read widely in travel literature for the play—and Brereton's *Briefe and True Relation of the Discoverie of the North Part of Virginia* (1602) was available. It is a nice thought that some of the lushest imagery of Prospero's island of exile is our very own Vineyard. Juicier berries than in England, Brereton wrote, and "vines in more plenty than in France."

The quest for gold was dramatized by a famous incident in 1611 in which a Vineyard Indian, one Epenow, was forcibly captured by a visiting English ship and the man taken to England and exhibited. He was "a man of so great a stature, he was shewed up and downe London for money as a wonder." He was also interrogated as to the whereabouts of gold on his island. A fast learner, Epenow told his captors that indeed he did know where gold was to be had, and he was very soon transported back a year later by another greedy captain to find the gold. The ruse worked, and with the help of his fellow tribesmen in dugouts, and volleys of their arrows, Epenow escaped as soon as he was in sight of his home island.

There had to have been an extensive oral history of the comings and goings of the European fishing fleets, because there is no record of the Indians of the Vineyard being shocked or surprised by the appearance of the first foreigners on the Island—the dramatic encounter known to anthropologists as First Contact. A more common occurrence was that Europeans came ashore throughout the 16th and 17th centuries and discovered that the Indians spoke some English. In some places Gosnold was confronted by confident nattily turned out and well-shod natives; and in early 1621 Myles Standish of the *Mayflower* met Samoset, who said, "Welcome. You from England? I know some Englishmen." In general, the Indians seem to have been justifiably indignant that their land was being occupied. But no land was privately held, it all belonged to the sachem and it was the sachem who allowed the foreigners to come ashore.

The course of Martha's Vineyard history was set when it was purchased, along with Nantucket and the Elizabeth Islands by an enterprising immigrant from Wiltshire, via Medford, named Thomas

Mayhew. This was in 1641. As I say, the past exists in the present. Three hundred and sixty-three years later the Island is still the home of many Mayhews, descendants of the original settler and patriarch, whose mission was to settle and colonize the Island, and to convert as many Indians as possible. One example of Mayhew's success in winning over the majority of Indians was demonstrated during King Philip's war. This unsuccessful Indian rising, led by the great Wampanoag sachem Metacomet (King Philip) on the mainland against the English in 1675–76, was intended as a war of extermination. But the Vineyard Wampanoags refused to be recruited, and those who participated in the war chose the English side–some of them were in fact armed by the settlers to resist the uprising of their own kinsmen.

From the beginning of its settlement the Vineyard pursued both agriculture and fishing. This pattern persists to the present. The tilled land now was tilled land then and some sheep farming still remains up-Island. Nantucket, a featureless moorland, with fiercer Indians and an inconvenient harbor had almost no agriculture. Even after Nantucket was discovered and settled its main harbor possessed such an obstacle to ships in its shallow harbor entrance that for many years Edgartown on the Vineyard served as Nantucket's port for the fitting-out and unloading of whaling ships. Mayhew had chosen Edgartown as his chief harbor, calling it Great Harbor.

The other significant harbor was not Vineyard Haven but a coastal indentation, with some added pilings and wharves, to the west, now called Lambert's Cove, chosen for its nearness to the up-Island farming community at West Tisbury. The village green, the classic Greek Revival houses, and the whaling church at Edgartown clearly reflect the town's prosperous past. In Mayhew's day there was an Indian settlement at Aquinnah–formerly known as Gay Head–and this is still the case, as it was in Melville's day when he described the *Pequod's* harpooner. "Tashtego, an unmixed Indian from Gay Head, the most westerly promontory of Martha's Vineyard, where there still exists the last remnant of a village of red men, which has long supplied the neighboring island of Nantucket with many of her most daring harpooners."

The earliest settlers found two or three thousand Indians on the Vineyard, but these numbers were drastically reduced when they began to die from illnesses introduced by the foreign newcomers. They were Wampanoags, associated with the larger nation of people living on the Cape (who are still there, mainly around the town of Mashpee). They spoke an Algonkian language, which is preserved in many place names, and they lived in a loose association of communities on the Island that they knew as Capawack or Noe-pe, under the leadership of local sachems. In their settlements were rounded huts of bent saplings covered with stitched-together mats to keep out the weather.

Inside the huts the foreign visitors noted flourishes of "Deeres feet . . . harts hornes and Eagles clawes." Wooden bowls and trays, and well-made baskets, and clay pots, many with chevrons or lines scored upon them, were used for food. The women wore deer-hide skirts and the men loincloths and leggings of animal skins. The men painted their faces–whitened their eyebrows for effect. Some wore eagle claws and necklaces of white bone beads. They had copper, and some possessed European fripperies and implements, which must have been gotten as tokens in trade from the mainland, the evidence of the 16th-century visitors from Europe. Many of these artifacts have been found in archaeological digs on the Vineyard, some at Squibnocket, others nearer Vineyard Haven.

The Vineyard Wampanoags smoked tobacco in pipes they made, they carried the tobacco on them in leather pouches. They foraged for berries and grapes. They fished and traveled on the ocean in dugout canoes that they fashioned from enormous logs, burning the insides then hollowing them out with adzes. They were adept at fire-making, using the percussion method for producing sparks, an iron-pyrites anvil in one hand, and a strike-a-light of flint or quartz in the other. One bewitching habit of theirs disturbed the early settlers: the Wampanoags sang at night–every night–"they sang themselves to sleep." (Henry David Thoreau noticed this same trait while traveling in the Maine woods in 1857, his Abenaki guide singing at bedtime.) The English proselytizers were contemptuous of the fact that the Wampanoags "were mighty zealous and earnest in the Worship of False gods and Devils." They worshipped thirty-seven deities. "They could have one," the evangelists reasoned. Some made the choice and a significant social distinction was made between Praying Indians and Heathen Indians.

For their survival, the settlers studied and imitated the Wampanoag agricultural skills, growing corn and beans and

squash, and especially enriching the soil by using herrings and shad as fertilizer. Recent carbon dating of disinterred objects has shown that these native people have lived on the Vineyard for more than 4,000 years. Discovered in the excavations on Squibnocket in the 1960s were hearths and earth ovens, middens of shells and animal bones, especially white-tailed deer and gray seals, which comprised the predominant diet. Stone knives and arrowheads, were also found, awls shaped from deer ulnas, notched net sinkers, fine scrapers, choppers, bird bone beads, pipe stems, adzes, pot sherds, carved bone pendants. The culture was complete and self-sustaining.

Weapons were also unearthed—hefty spears and javelins, which seemed to indicate a culture of hunters, rather than of fishermen. Some small fish hooks were found but the principal method for catching fish was the weirs built by the Wampanoags on various places on the shore, trapping fish in the outgoing tide. Circumstantial evidence shows the people were reverential in burying their dead, in some cases elaborately, with tools and bowls and personal items. One of the strangest and most poignant finds was a dog's grave on an ancient site near Vineyard Haven. This "carefully buried body of a medium-sized adult dog . . . [was] probably a pet," it was noted, a dramatic example of a "sentimental regard for this helpful ally of the hunter."

In general, the Wampanoag settlements became the settler villages of the Vineyard and ultimately prospered as Oak Bluffs, Edgartown, and Vineyard Haven. The Indians remained dug in at the farther places, Chappaquiddick and Aquinnah, off the road and isolated, and the Praying Indians congregated in purpose-built settlements such as the unambiguously named Christiantown, adjacent to West Tisbury, which lasted 228 years, dissolving in 1910. Edgartown retains its distinct air of prosperity in the dignity of its houses, the charm of its narrow streets, and the harmony of its architecture. It has perhaps been preserved through the sheer accident that it cannot accommodate the large car-ferries, and it sometimes seems as though the last whaler has just sailed away.

Vineyard Haven, which is more correctly Tisbury, is a workaday and unprepossessing town, and has assumed preeminence as a harbor and commercial center, the destination of most of the ferries and car

traffic. Boats are still built in Vineyard Haven, and fishing vessels still unload their catch. Because of its generous proportions the harbor can be busy without seeming crowded. Oak Bluffs lies between these two towns, with a character all its own, a ferry service, and a predominantly African-American population. Its architecture of tiny gingerbread cottages that seems at first glance like a collection of doll-houses (its original name was Cottage City) dates from the late 19th century and is an outgrowth of the seasonal tent community of the Methodist revival meetings.

Up-Island is another world, mostly small rural communities that are singly little more than a lovely church and a crossroads and hidden-away houses. Several of these communities, Chilmark and West Tisbury, were for 250 years places where sign language was used as often as spoken English. Deaf settlers in 1690 had introduced a recessive gene and inbreeding created communities in which as much as one in four people could not hear. Commenting on Nora Ellen Groce's book, *Everyone Here Spoke Sign Language: Hereditary Deafness on Martha's Vineyard,* Dr. Oliver Sacks wrote that in "response to [the deafness] the entire community learned Sign, and there was free and complete intercourse between the hearing and the deaf. Indeed, the deaf were scarcely seen as 'deaf'."

What impresses me is not that this is a sociological curiosity but rather the most humane example of a community acting together for the common good—benign, considerate, neighborly, peace-making; deciding on a common language and sticking to it for two and a half centuries. While I was writing this piece a memorial service was held for a retired and much-loved police chief of West Tisbury, George Manter. Eight hundred people turned out to pay their respects for this man. A Vineyarder who had been to this memorial service told me, "This is a close-knit community. I like the thought that I can depend on people here."

The year-rounders number about 15,000, and many of these people are the Island's aristocrats, "land rich and money poor," as one of them once told me: the dug-in gentry, with deep roots and a certain amount of influence, much of which they expend battling off-Island developers who want to put up trophy houses and golf courses. Many Mayhews are still there after ten generations, along

with descendants of the other folk who settled the Island, the Athearns, the Pooles, the Cottles, the Nortons, the Peases.

These native sons and daughters must not be confused with the more recent luminaries, the past century or so of celebrities, starting with Joshua Slocum, who circled the globe single-handedly in the *Spray* and wrote a wonderful book about it, *Sailing Alone Around the World.* Slocum bought a house and began farming in West Tisbury in 1902, the *Spray* moored at Menemsha, but he sailed away in 1909 and was never seen again. Jackie Kennedy had a house and a farm and a great deal of land up-Island near Squibnocket, and though she frowned on socializing she was the uncrowned queen of the Island until her death. But Vineyarders agree that it was Jackie's brother-in-law Teddy who put the Island in the news when he drove his car off the Dyke Bridge in 1969 and where his passenger, Mary Jo Kopechne, drowned. Then the whole world knew the word Chappaquiddick. And Jackie's son, John Jr., died with his wife and sister-in-law in 1999 when his plane crashed into the sea one summer night to the west of Aquinnah.

At first glance it seems to be an island of writers, of creative people, of liberal minds. This is not an illusion, though there is more to know than this. The *Vineyard Gazette,* the first newspaper on the Island, epitomizes these qualities, and as an articulate and dignified weekly newspaper (twice weekly in the summer) that has been the voice of the Island, continually published for 137 years. Up close the Island seems beset—by developers, golf nuts, speculators, the social services hard-pressed, and school teachers in short supply. Houses have become unaffordable and prices so high that local people routinely cross the Sound to Cape Cod to fill their cars and pick-up trucks with groceries. Many year-rounders contemplate the summer with horror, when on any given day the population exceeds 100,000 and the traffic is maddening and parking lots full and beach access obstructed.

"I love the winter," one said to me at the end of summer. "I am looking forward to January." She spoke of how melancholy the main streets of the towns are, with the boutiques and jewelry shops shut, the ice cream parlors and arcades closed, the summer people gone and their thousands of houses standing empty. "But there are all kinds of summer people," she went on. "A lot of them care deeply about the Island. They are part of the community. I don't know what we'd do without them."

Out of season it is hard to find an island quieter, more hushed or bucolic: the year-rounders repossess it then, when the many ancient dry-stone walls become more visible and assertive. The summer is its transformation. I cannot spend time on the Vineyard in those months without thinking how closely it resembles a summer camp, its seasonal residents like the friends I knew as a child when I was myself a camper. So summer people come to the Vineyard in a mood of excitement and eagerness, mainly to play, to see their friends, to socialize. I know plenty of year-rounders and their routines: they are workers. The summer people on the Vineyard I know are vacationers that are grateful for this chance to see friends from all over who rendezvous here once a year, in the same way that schoolchildren look forward to camp. The harsh New England winter, and the procrastinating spring, make us grateful for the summer, the magic of it, the liberating warmth, the foliage and flowers—all that and good friends together, an enchantment at its most intense on Vineyard days and Vineyard nights.

PAUL THEROUX

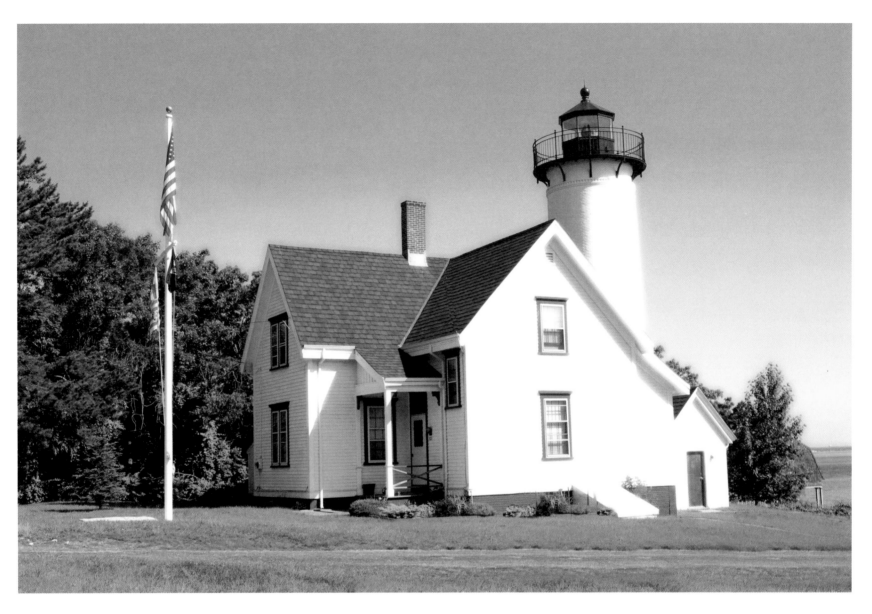

West Chop Light, Vineyard Haven

MORNING

Seth's Pond, Lambert's Cove

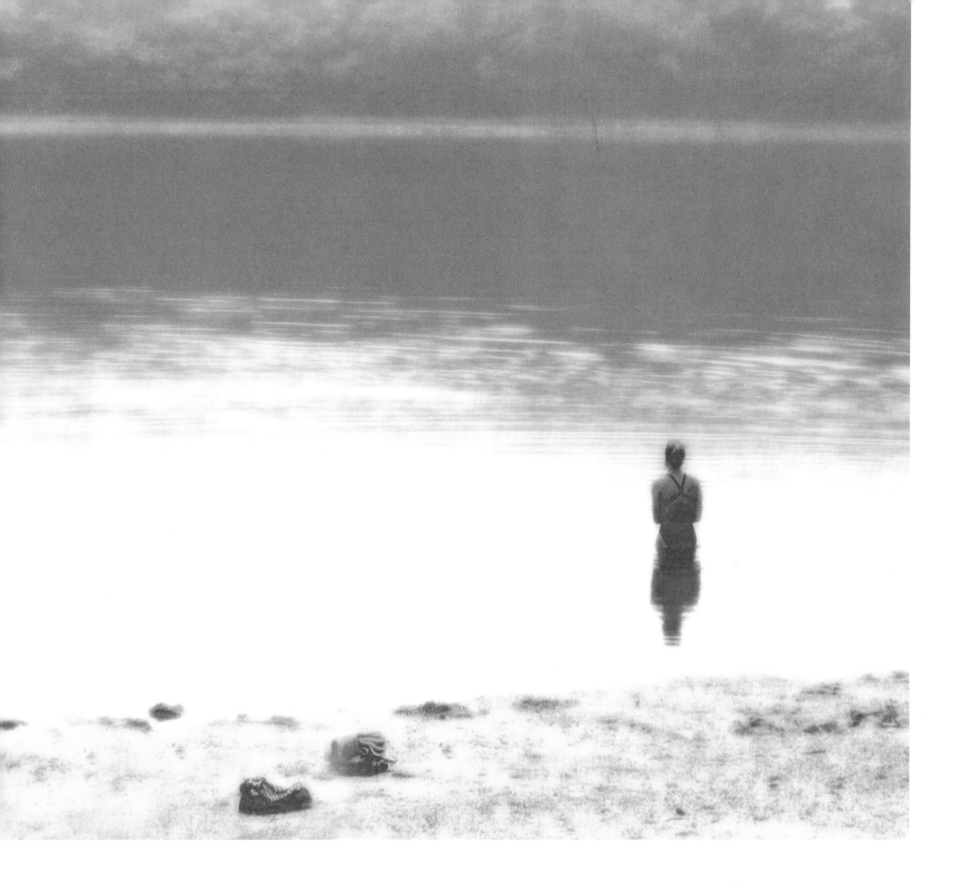

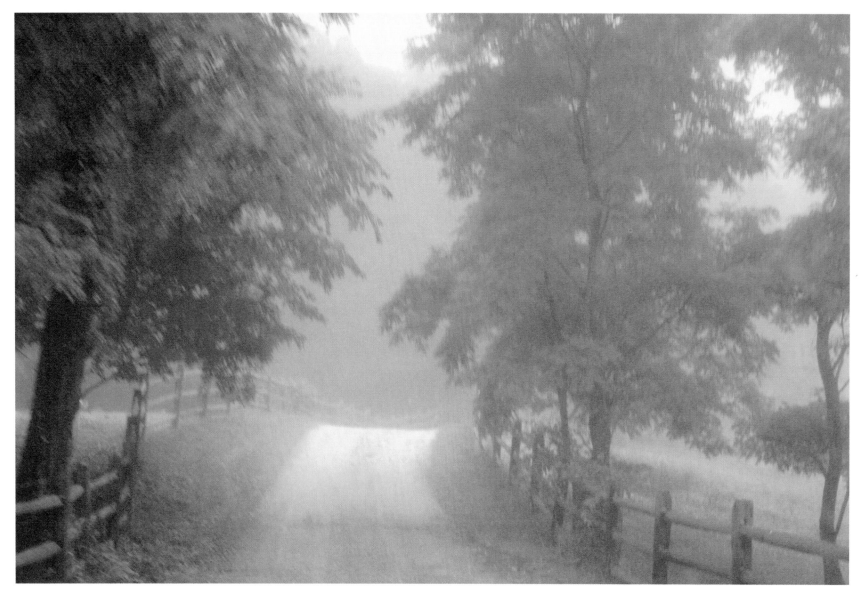

Pilot Hill Farm Road, Tisbury

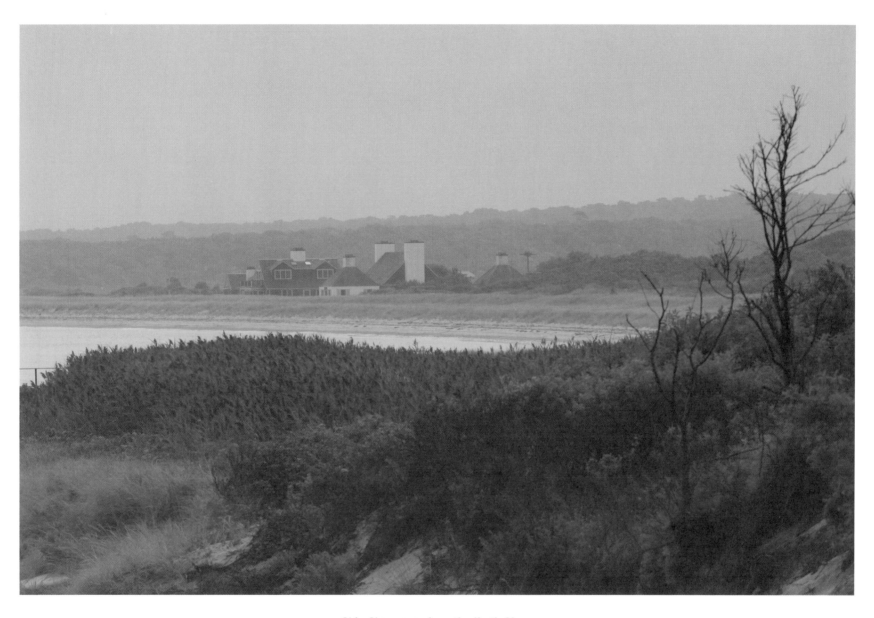

Chip Chop, seen from the North Shore

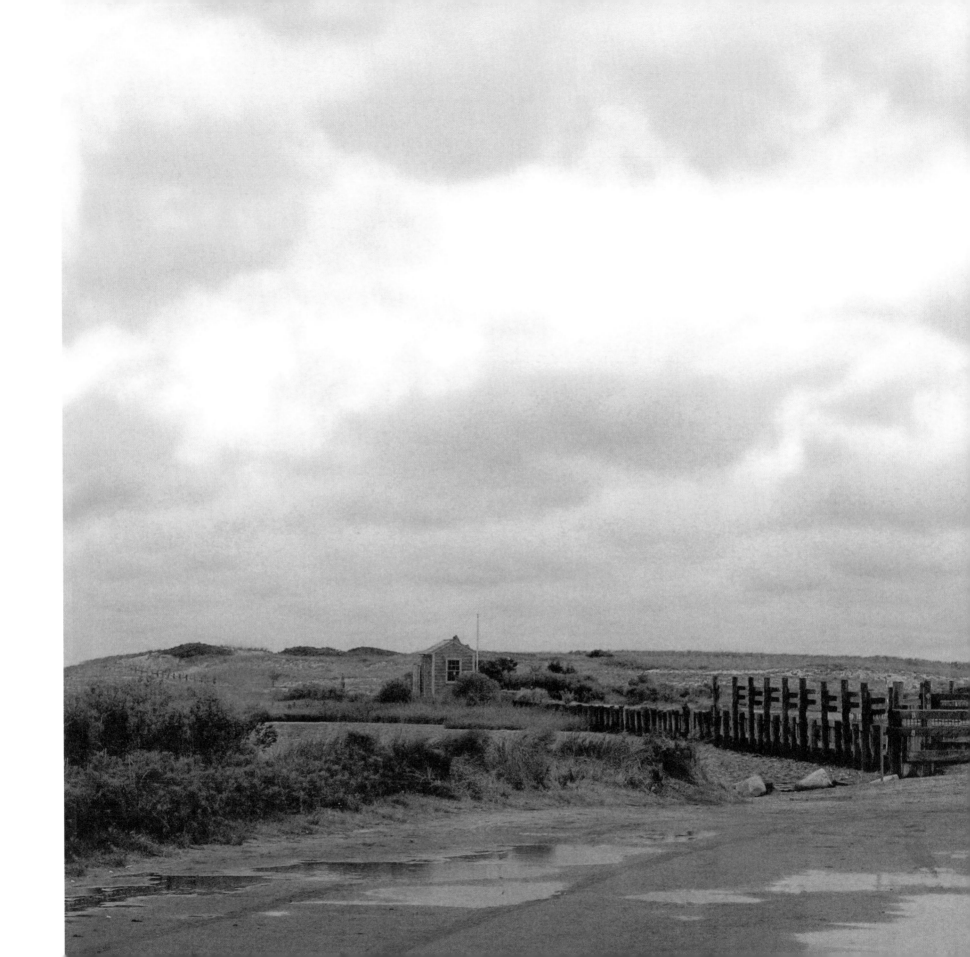

Dyke Bridge, Chappaquiddick Island

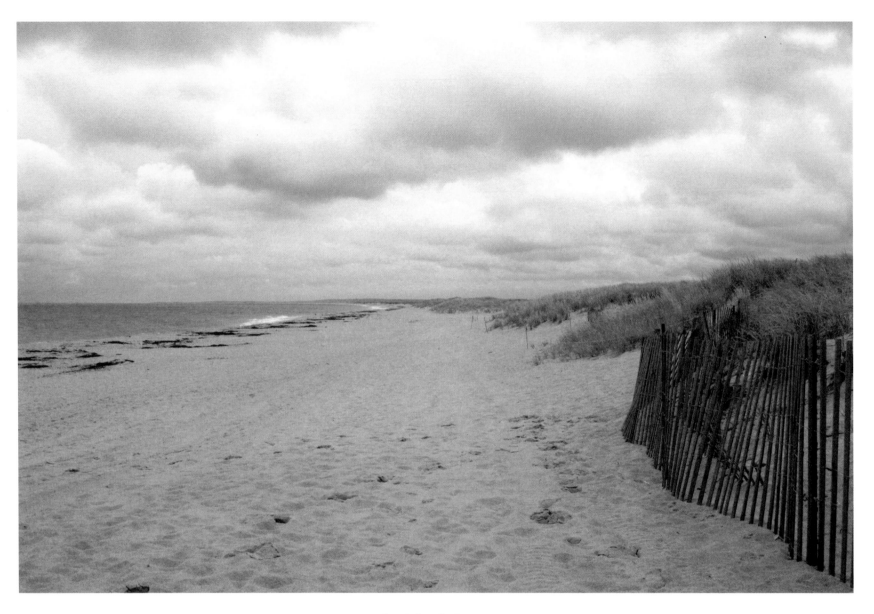

South Beach, Katama

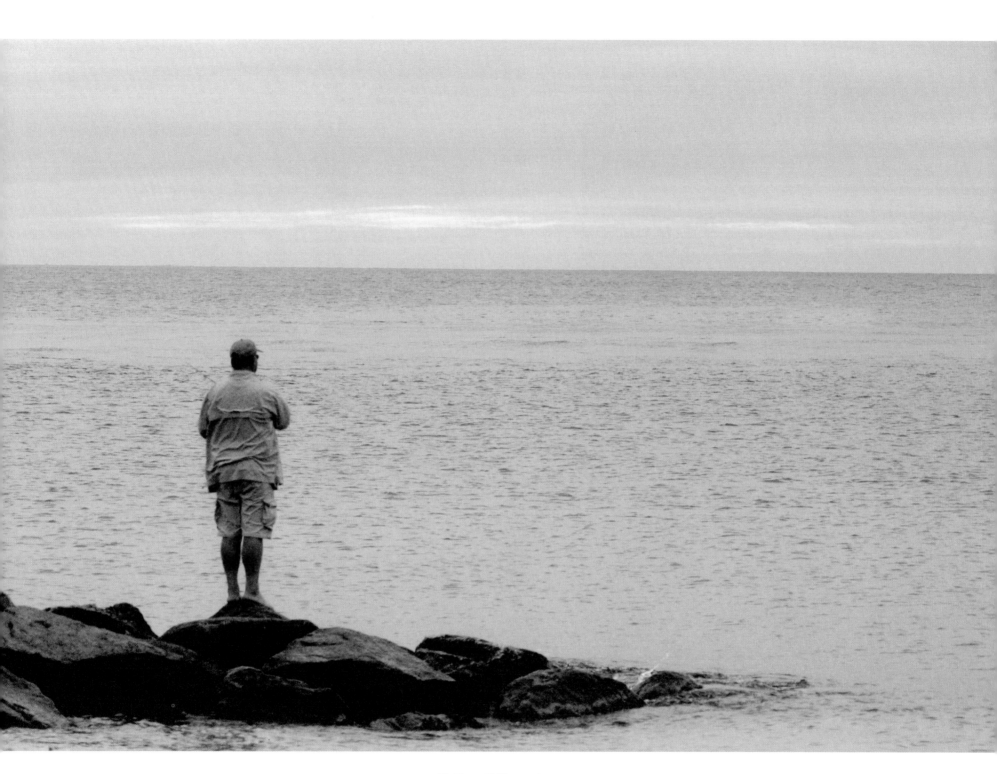

Fishing off Menemsha

Town Line, West Tisbury

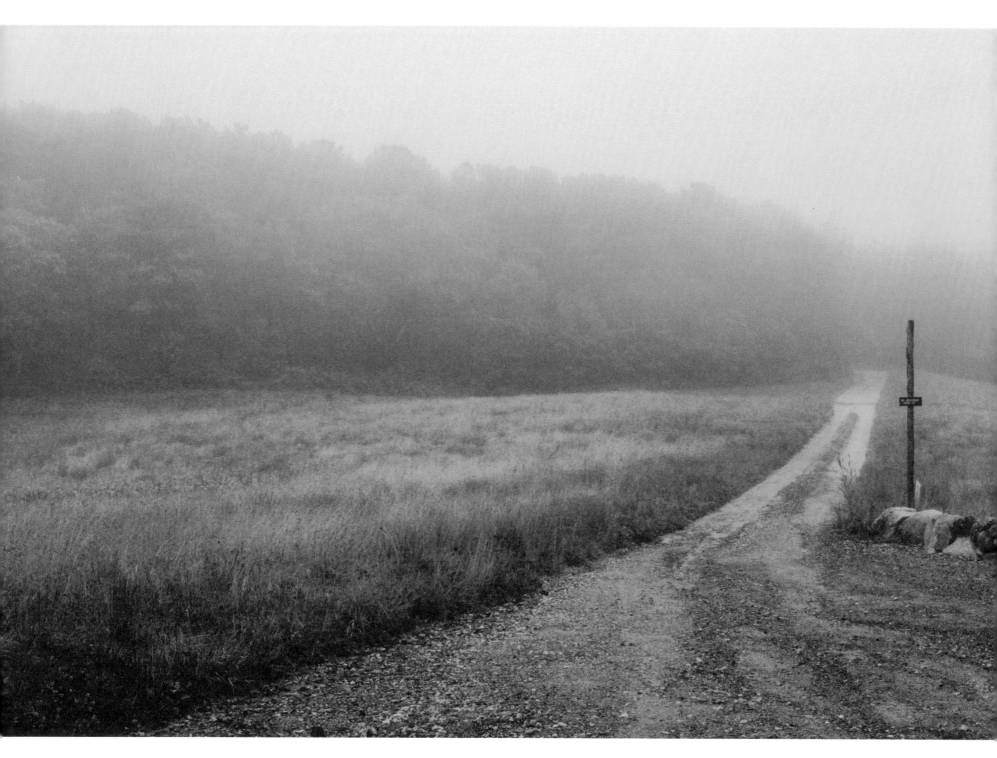

Dirt road off Lambert's Cove

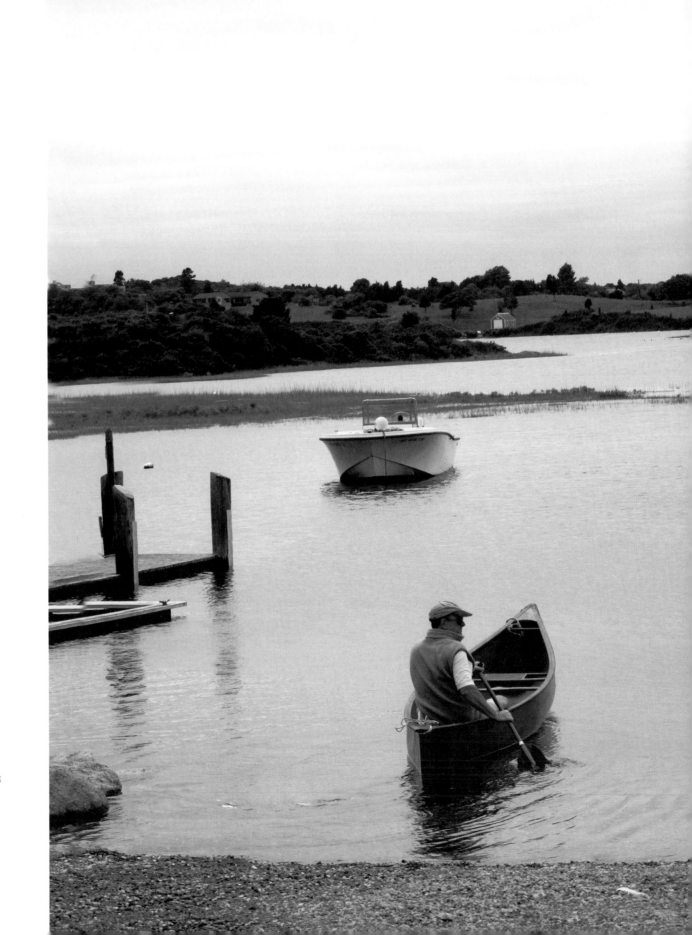

Quitsa Pond, Chilmark

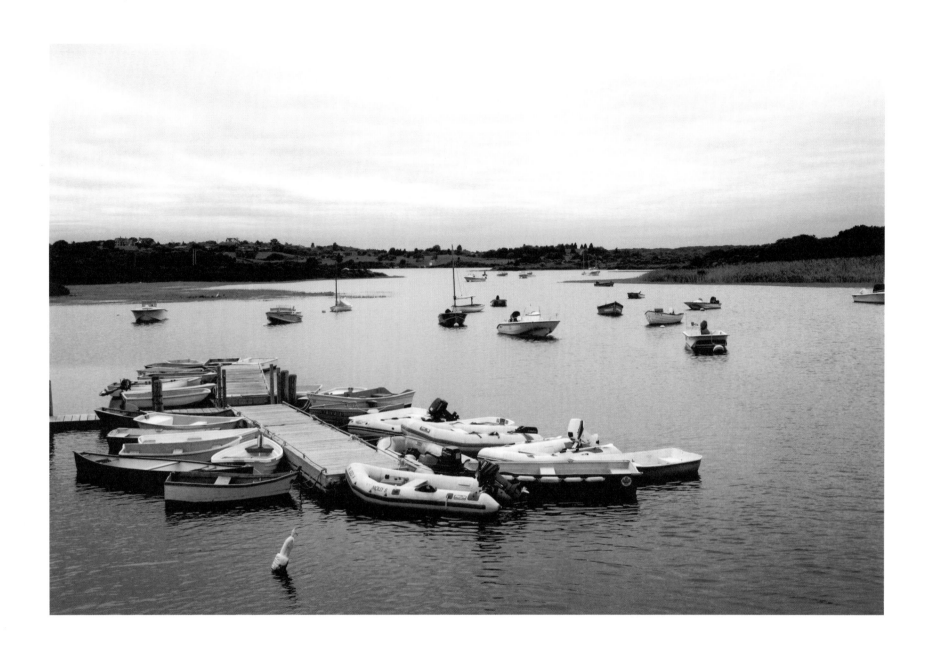

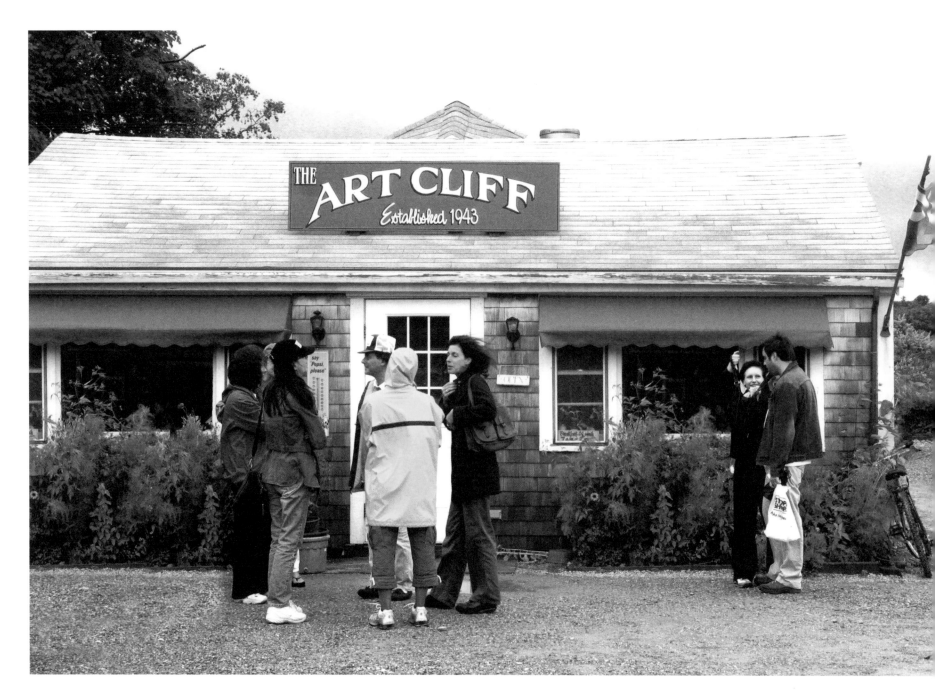

The Art Cliff diner, Vineyard Haven

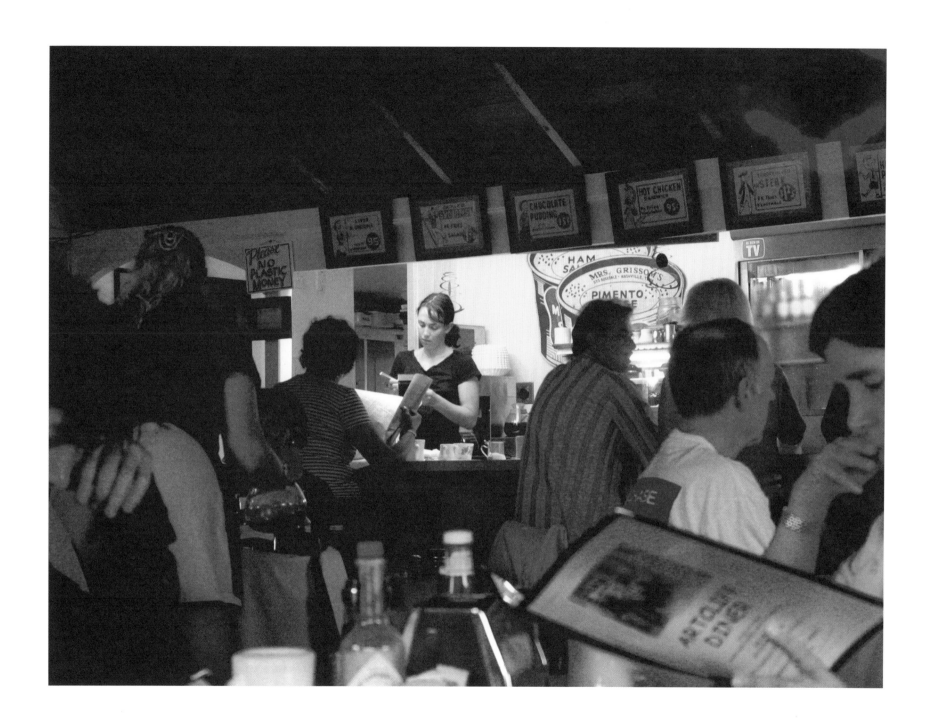

Fishing shack, Menemsha

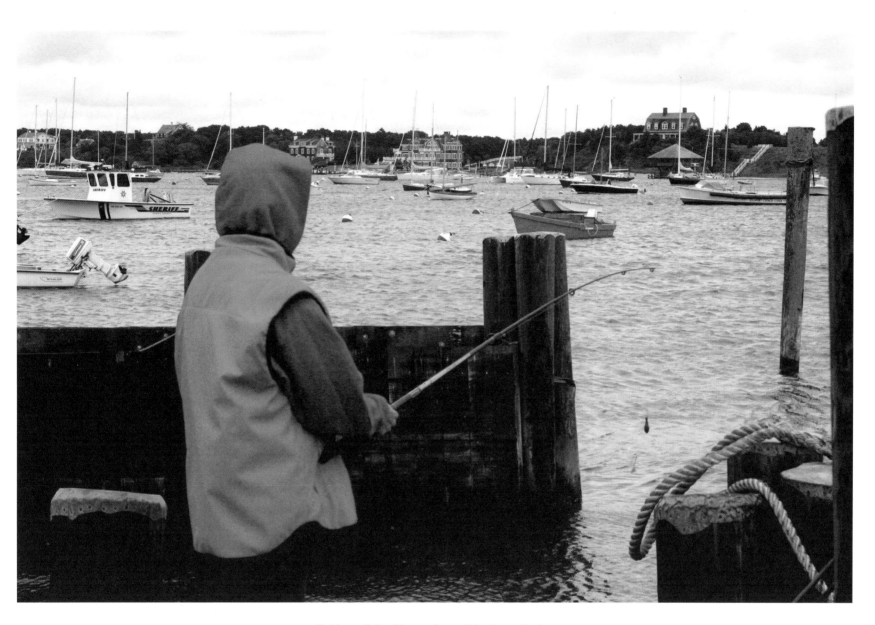

Fishing off the Chappy Ferry, Edgartown Harbor

Menemsha Basin, Chilmark

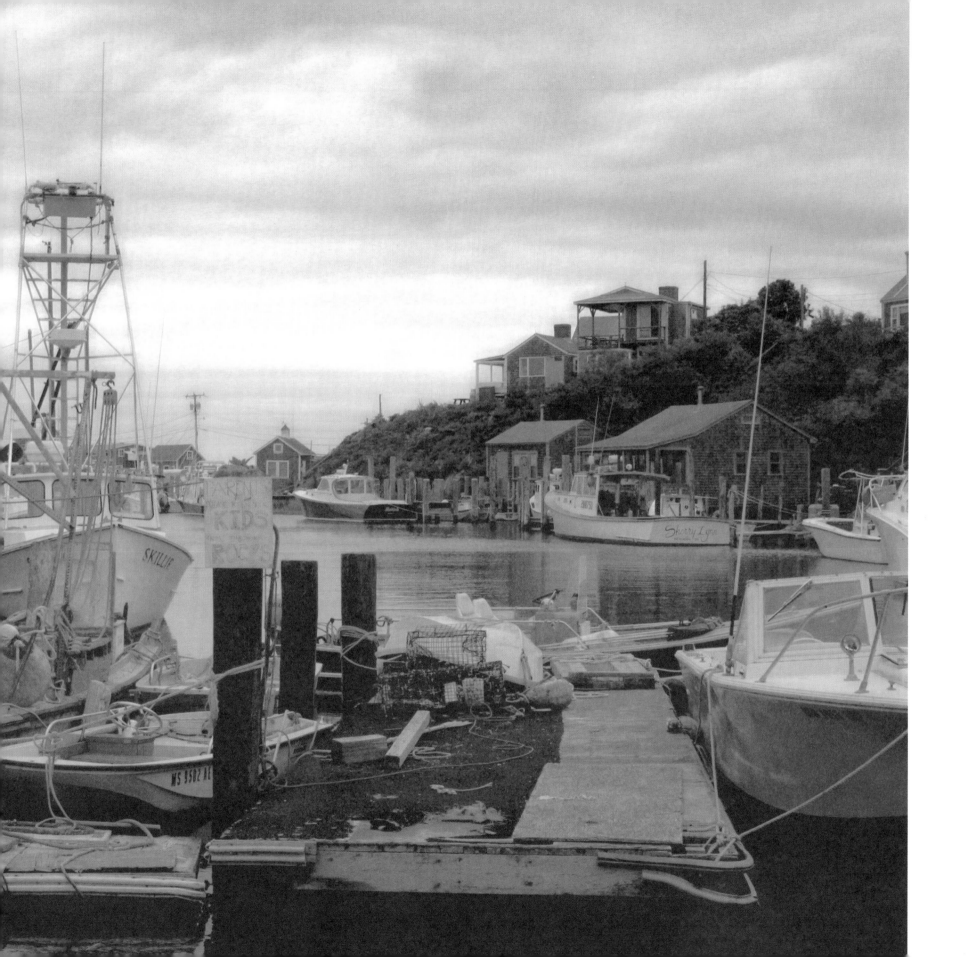

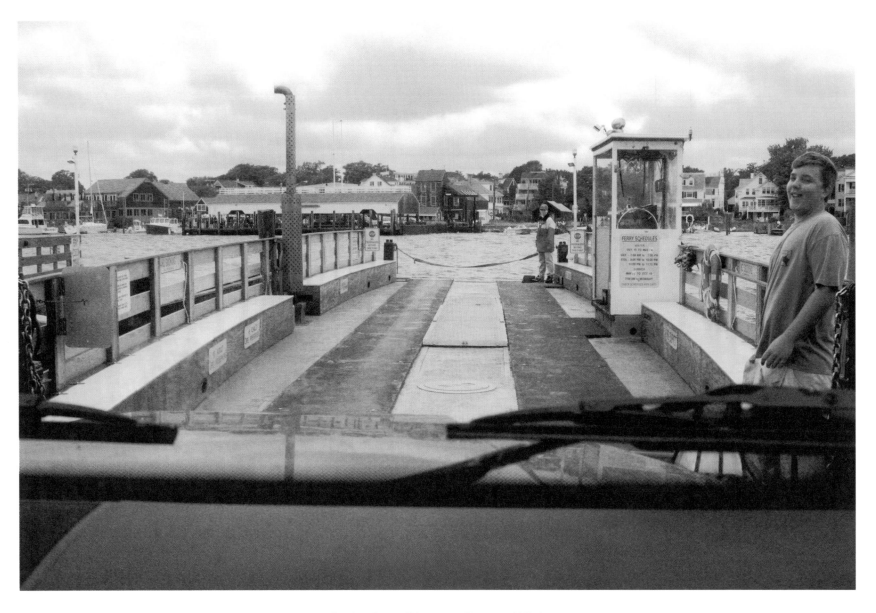

On-time Ferry, Edgartown–Chappaquiddick

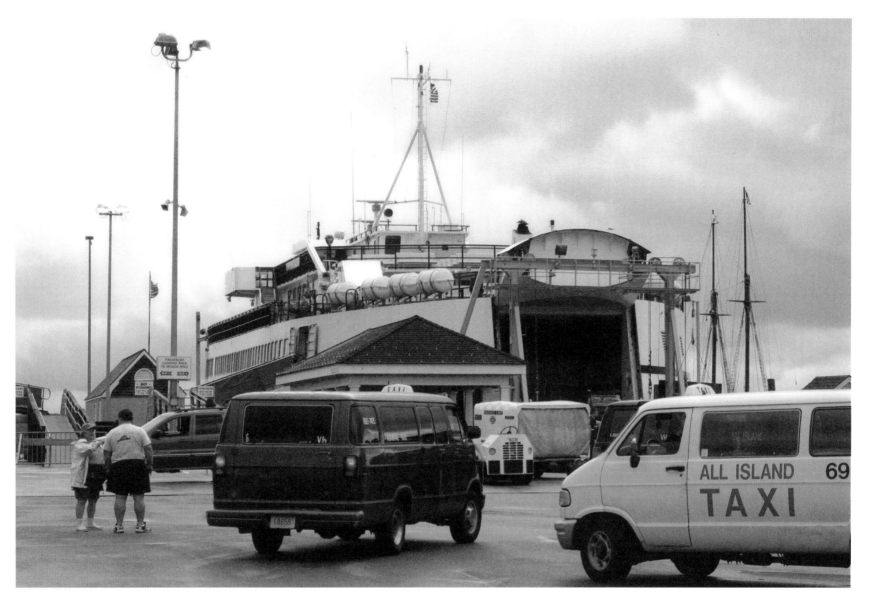

Woods Hole to Martha's Vineyard Ferry, Vineyard Haven

Chappaquiddick Beach Club

43

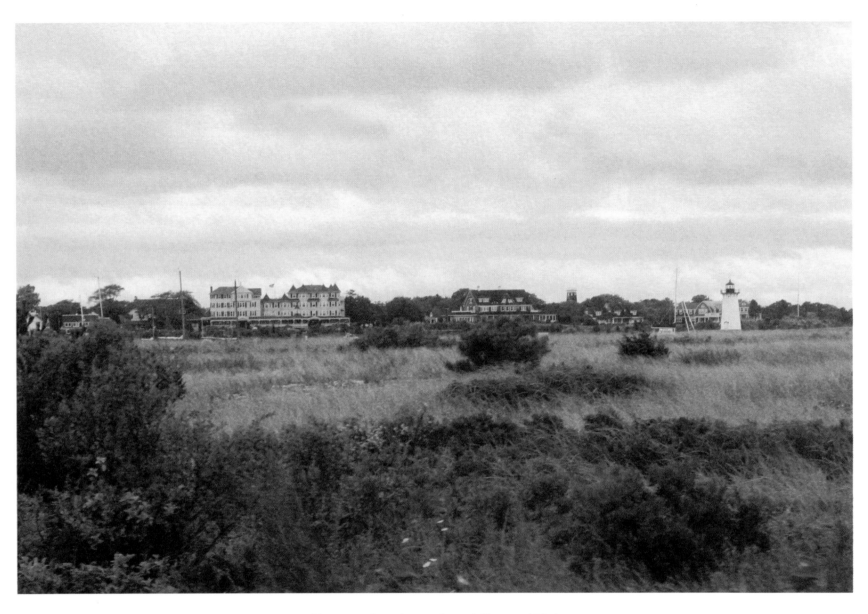

Edgartown, from the meadows of Chappaquiddick

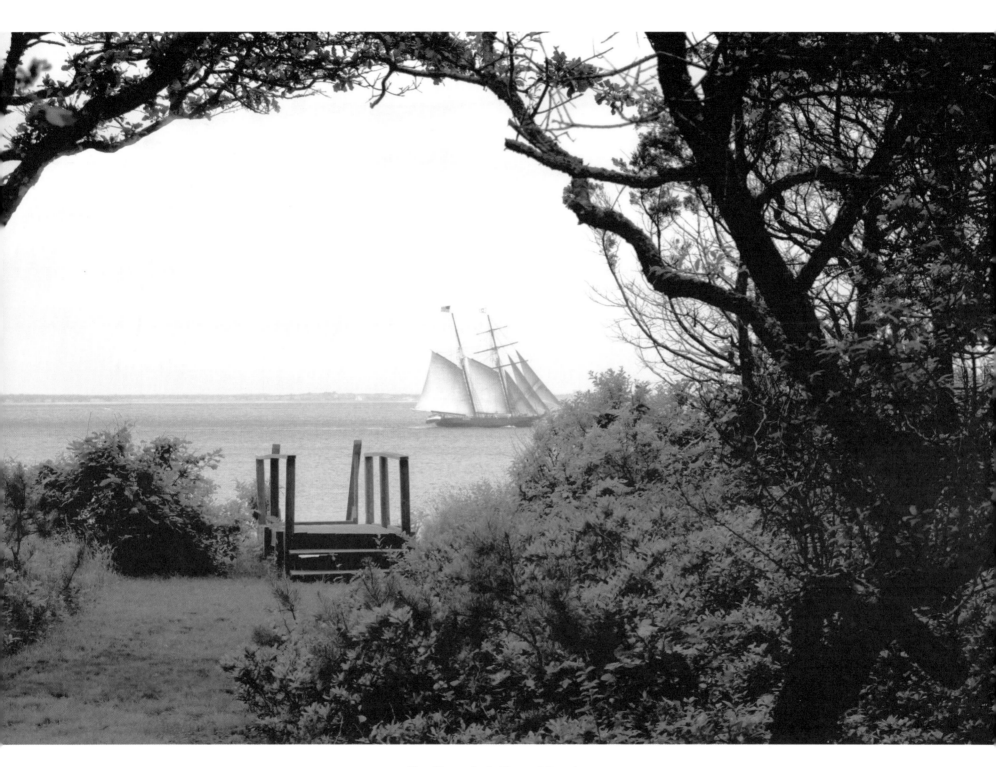

The *Shenandoah*, Vineyard Sound

Chappaquiddick Island, off Edgartown

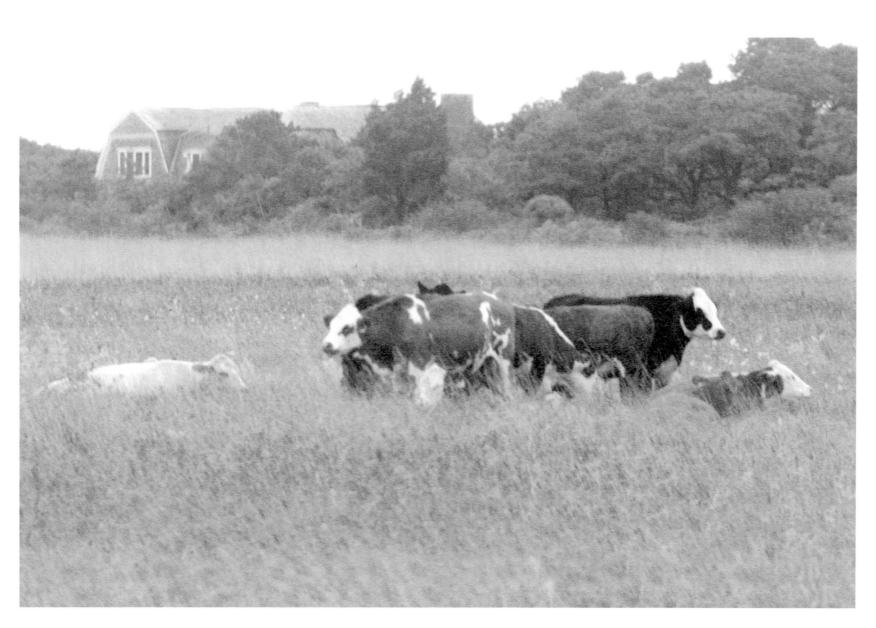

Cows grazing, Katama

The *Island Queen* disembarks, Oak Bluffs

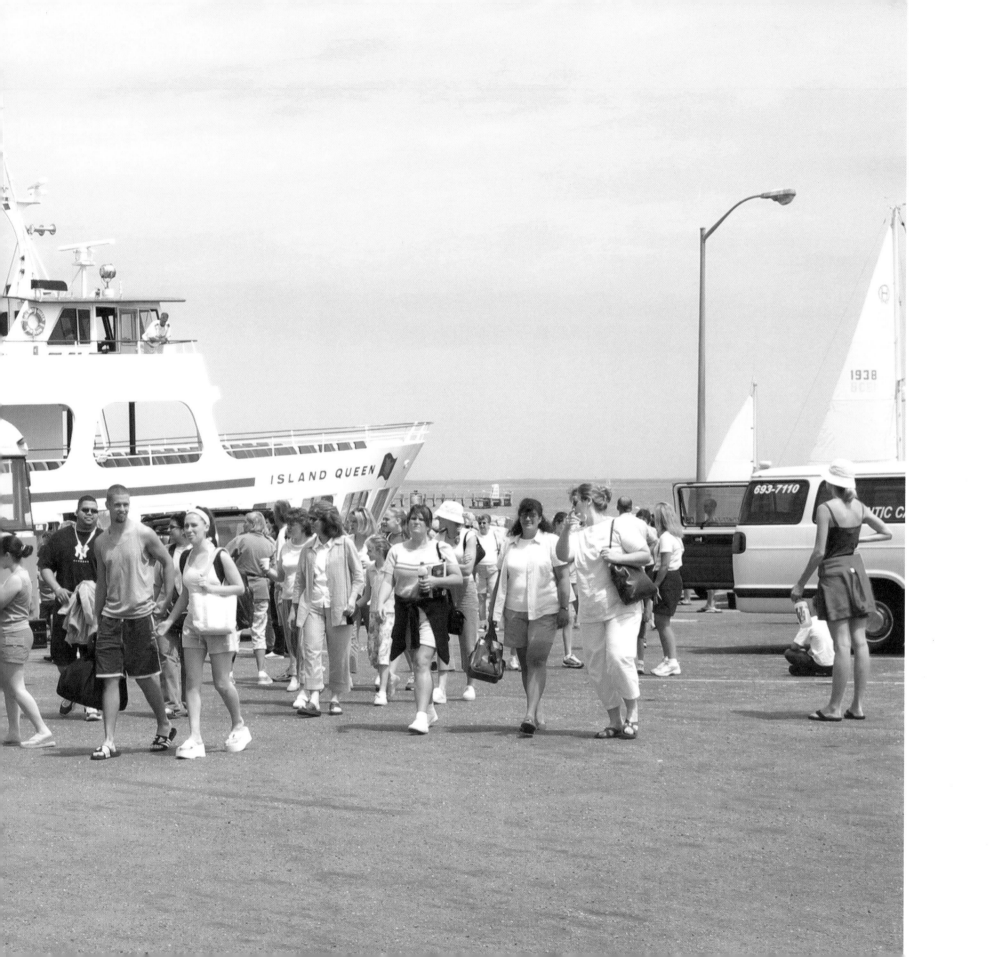

The Big Bridge, between Sengekontacket Pond and Nantucket Sound

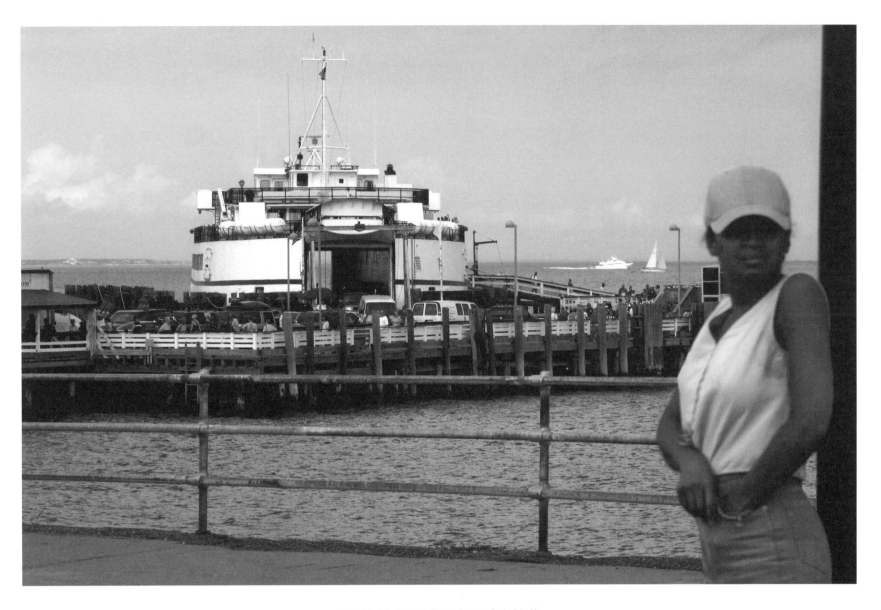

The 10:15 Woods Hole Ferry, Oak Bluffs

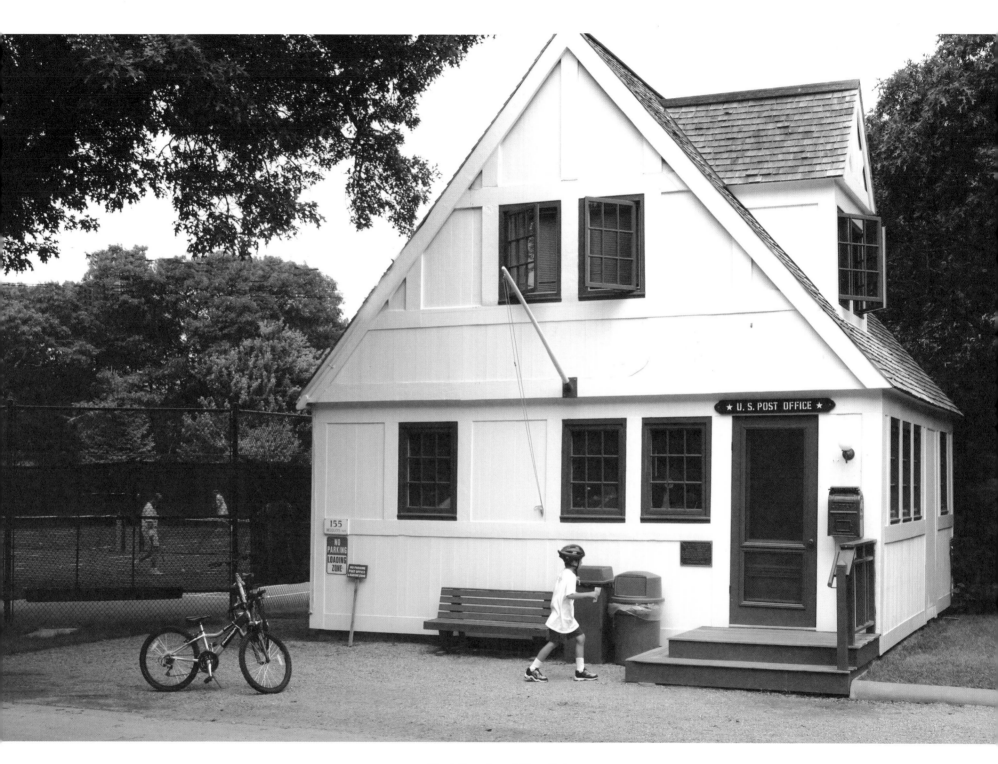

West Chop Post Office, Tisbury

Morning Glory Farm, Edgartown

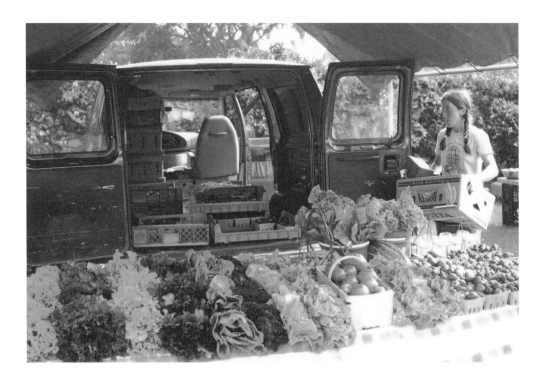

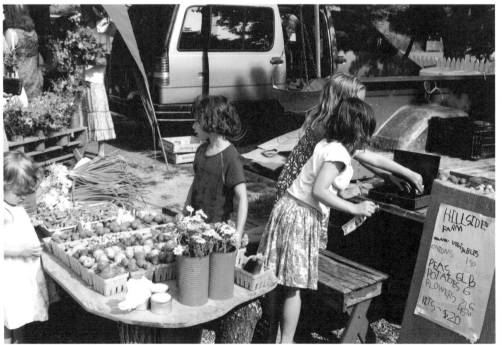

Farmers' Market, West Tisbury
Top: Blackwater Farm. Bottom: Hillside Farm

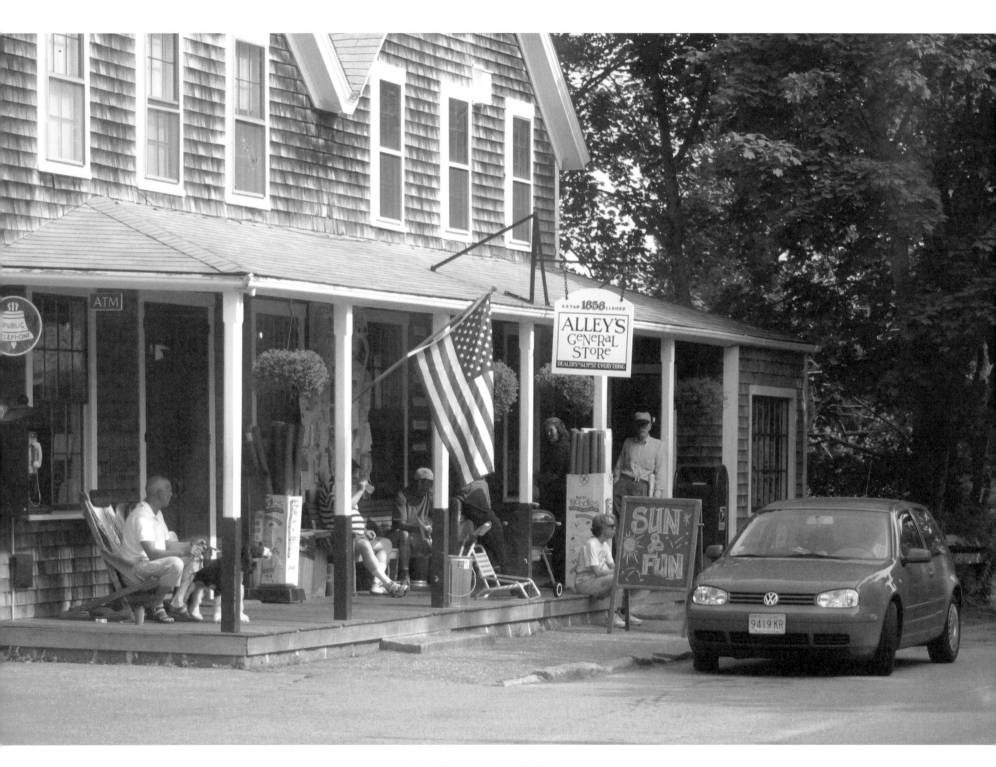

Alley's General Store, West Tisbury

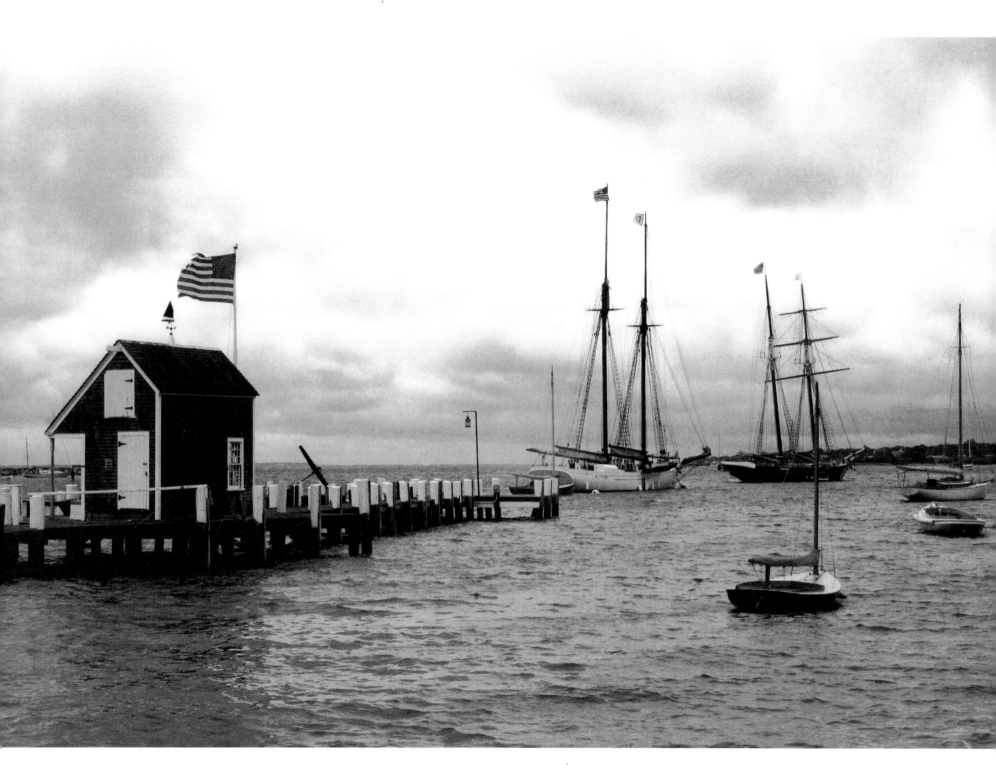

The *Alabama* and *Shenandoah* at anchor, Vineyard Haven Harbor

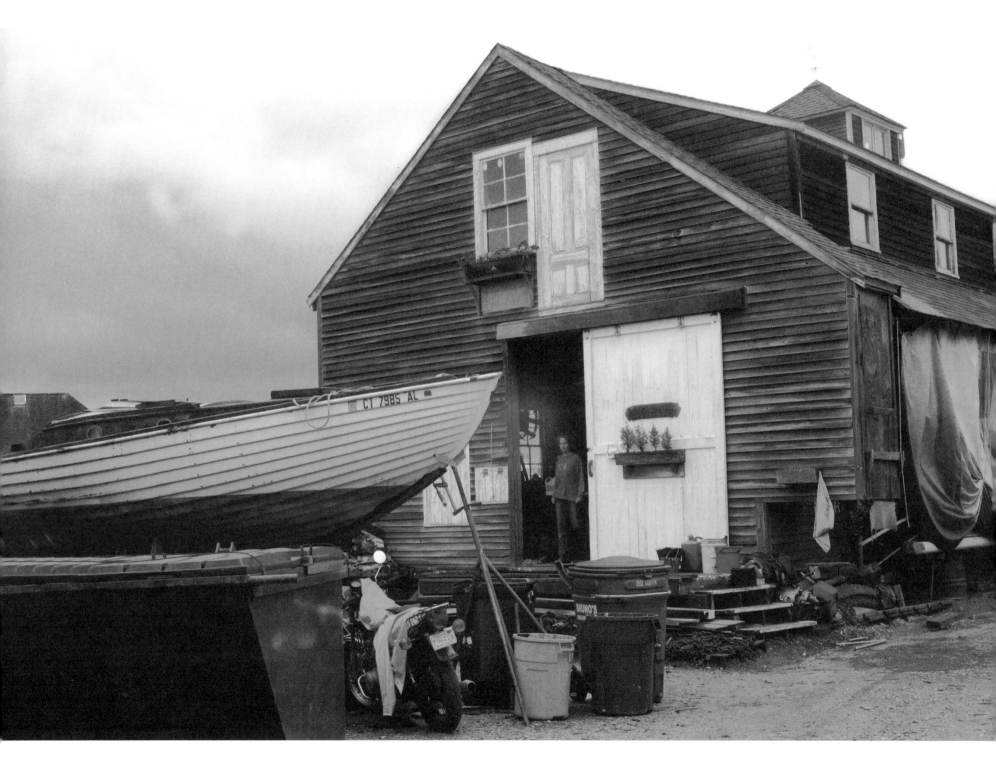

The Boat Yard, Beach Road

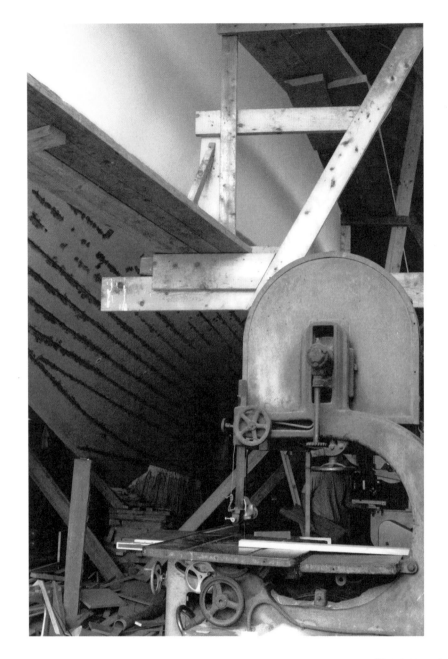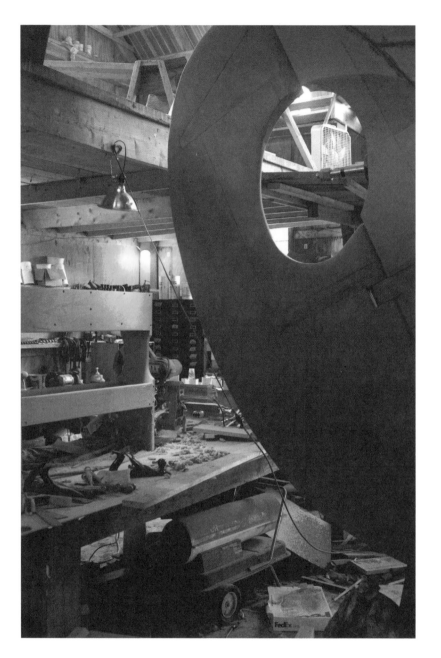

The *Juno* under construction

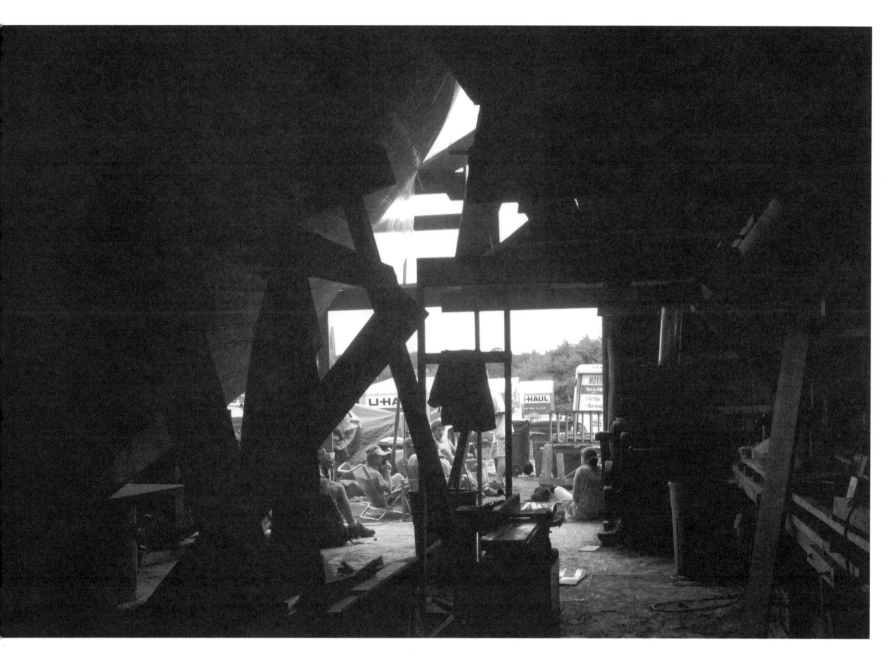

Gannon and Benjamin Marine Railway Annex, Vineyard Haven

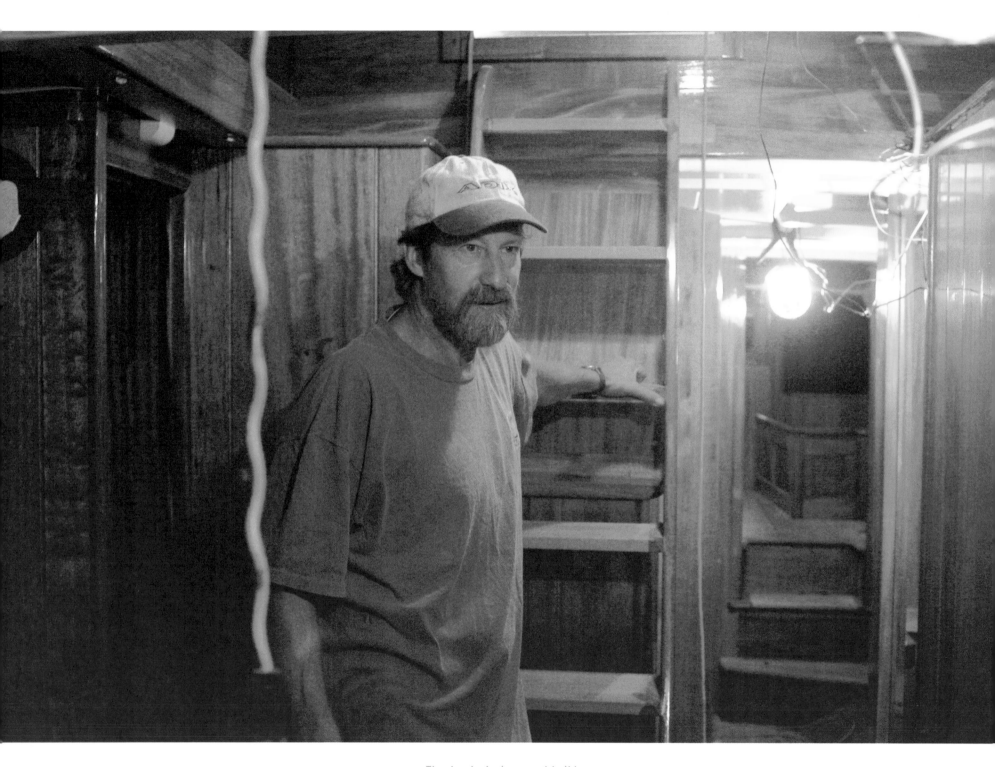

The *Juno*'s designer and builder

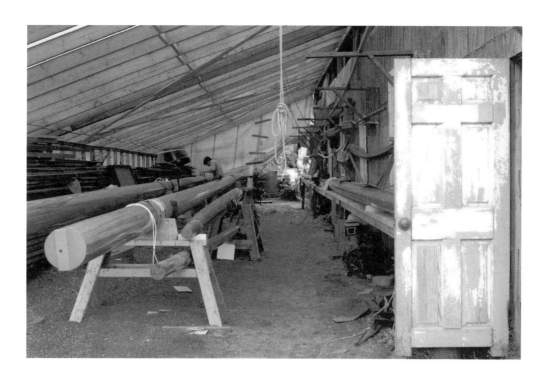

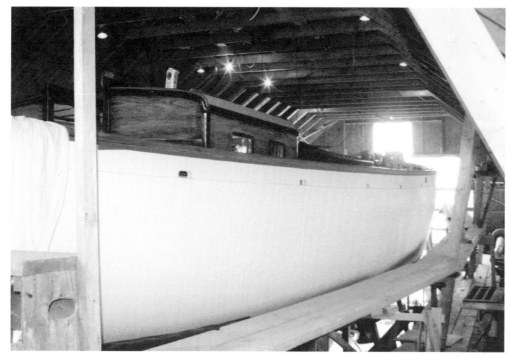

Top: Finishing the masts. Bottom: The *Juno* in its cradle.

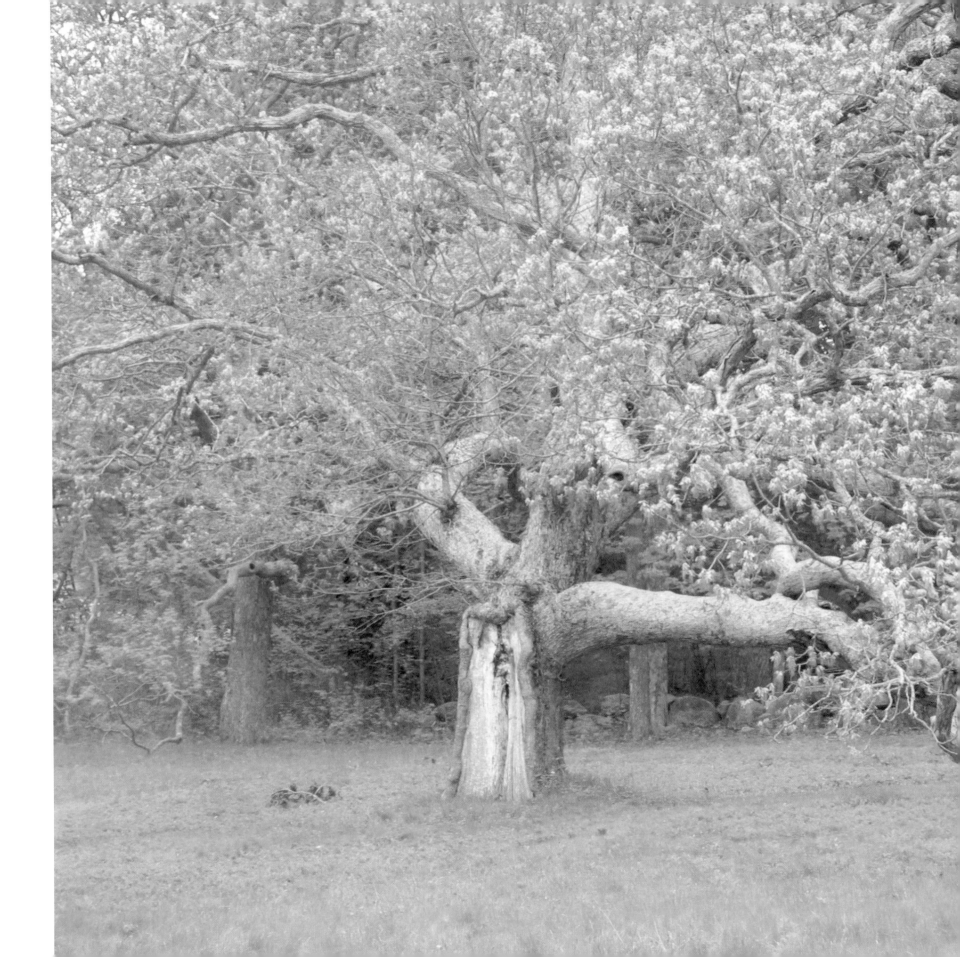

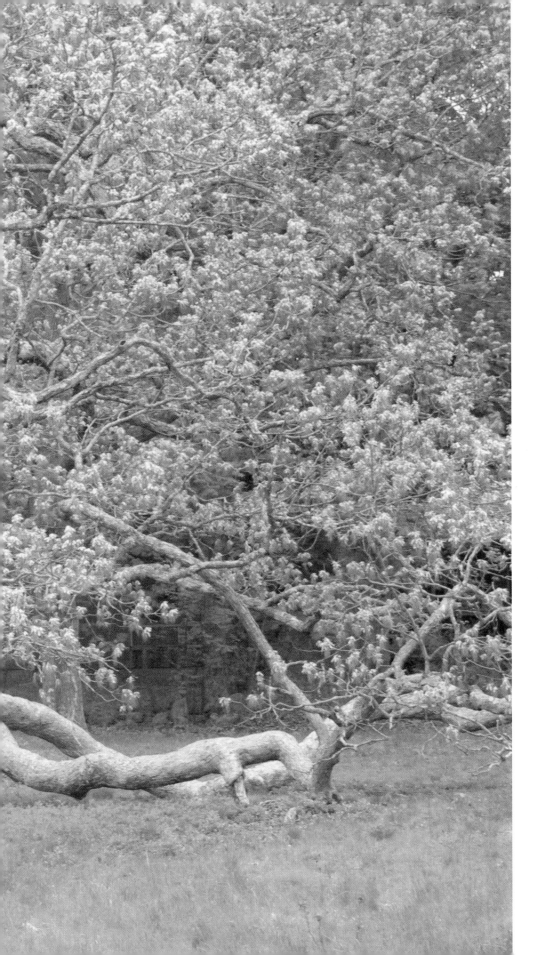

The Big Tree, West Tisbury

Pilot Hill Farm, Tisbury

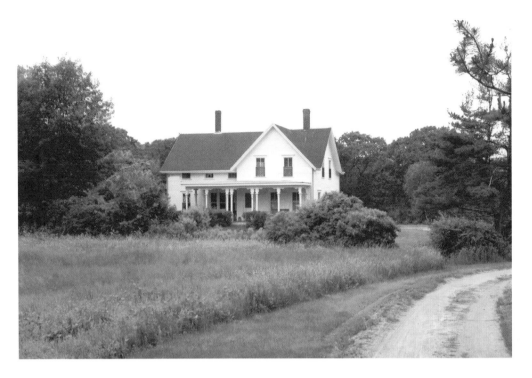

Top: Old farmhouse. Bottom: Wild stone wall.

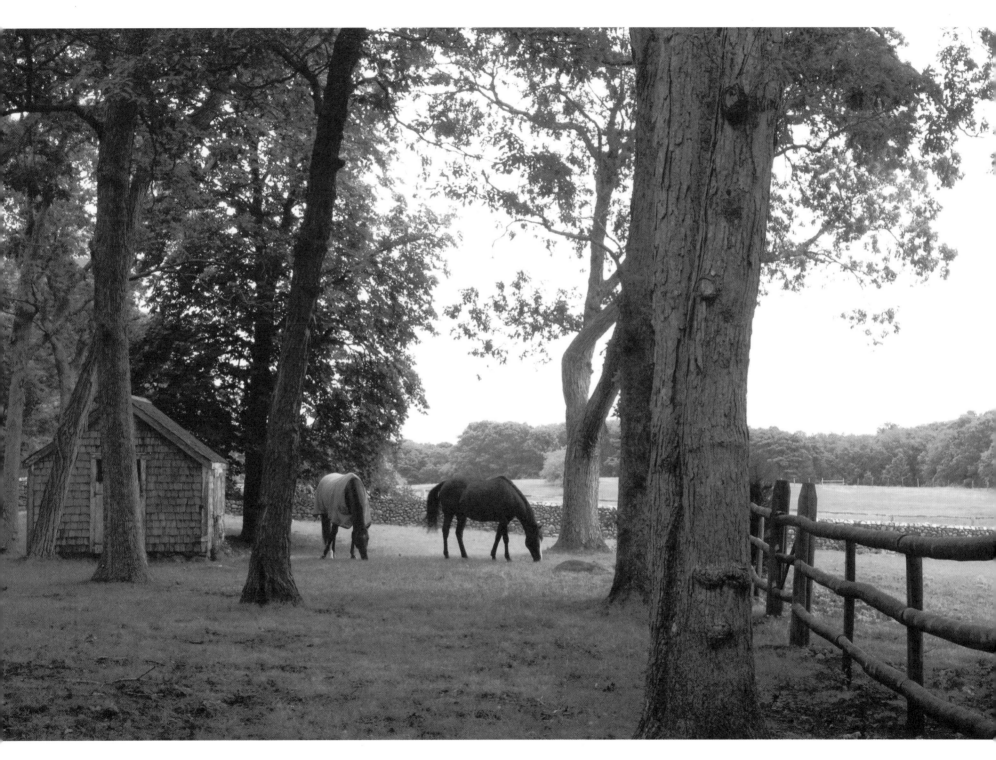

Tashmoo Farm, Tisbury

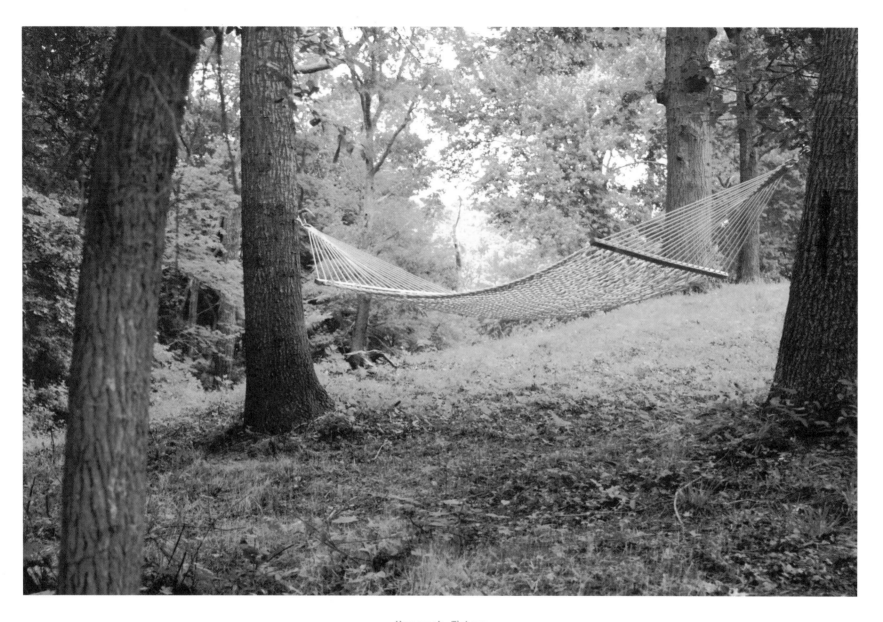

Hammock, Tisbury

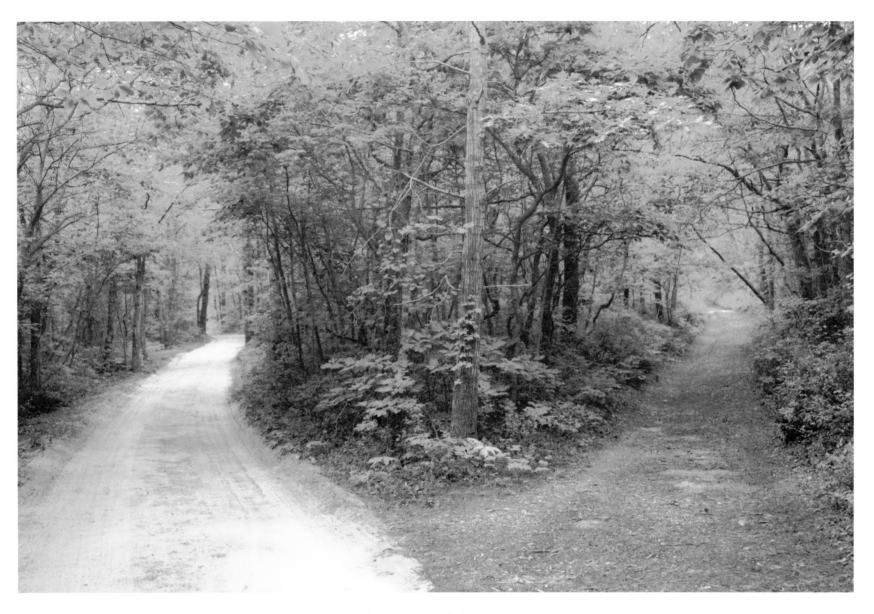

Road less traveled, Tisbury

Meadow off South Gate Road

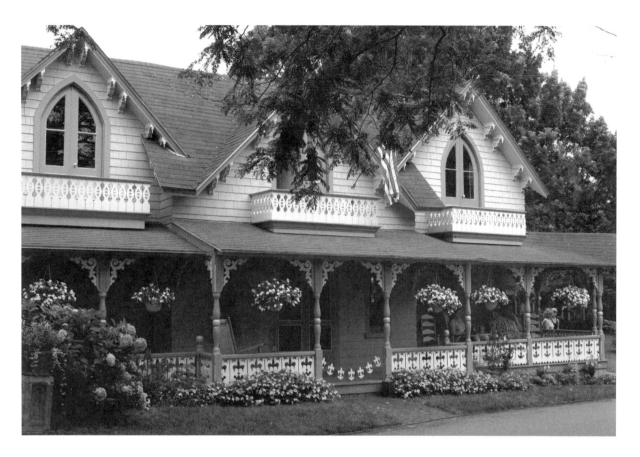

Gingerbread Cottage, Trinity Park, Oak Bluffs

Bandstand, Ocean Park, Oak Bluffs

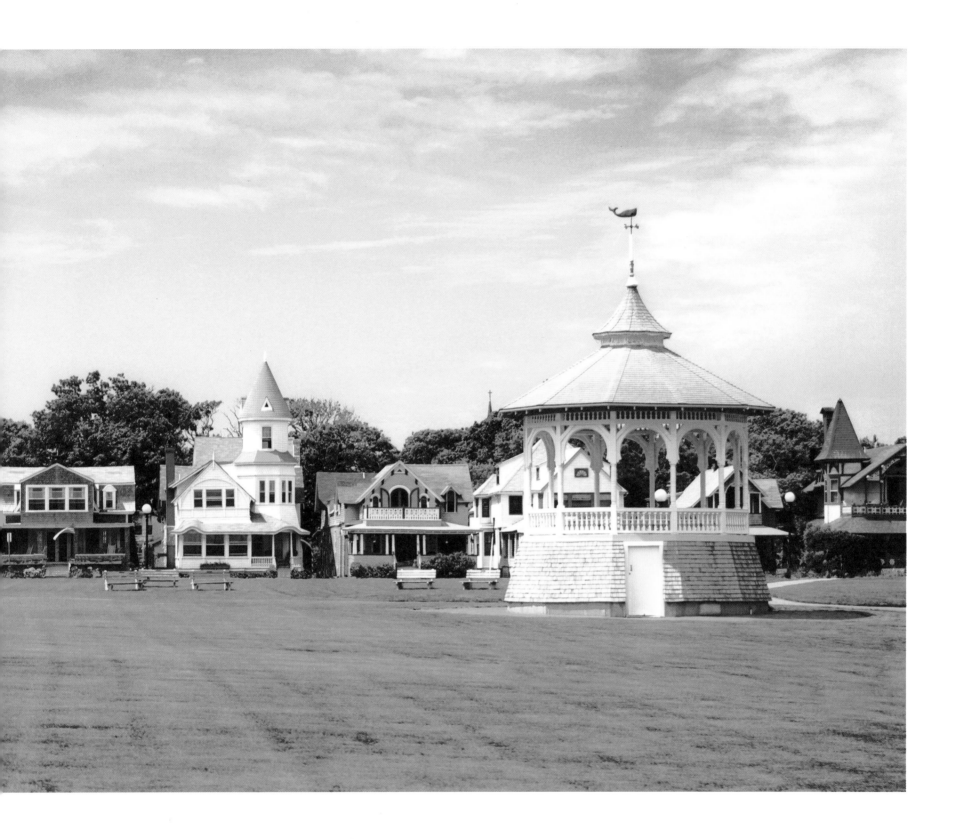

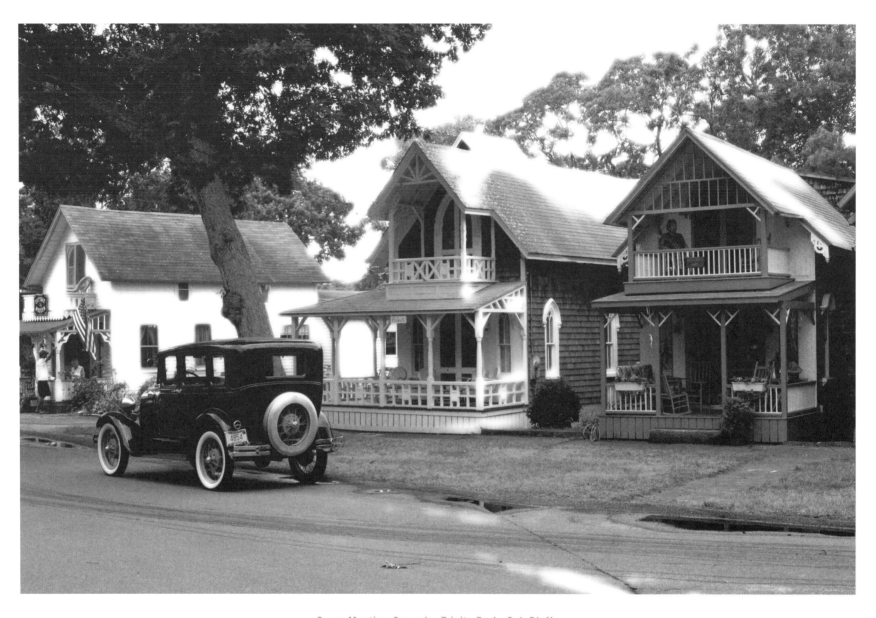

Camp Meeting Grounds, Trinity Park, Oak Bluffs

Andrew's room, The Ark, Trinity Park

75

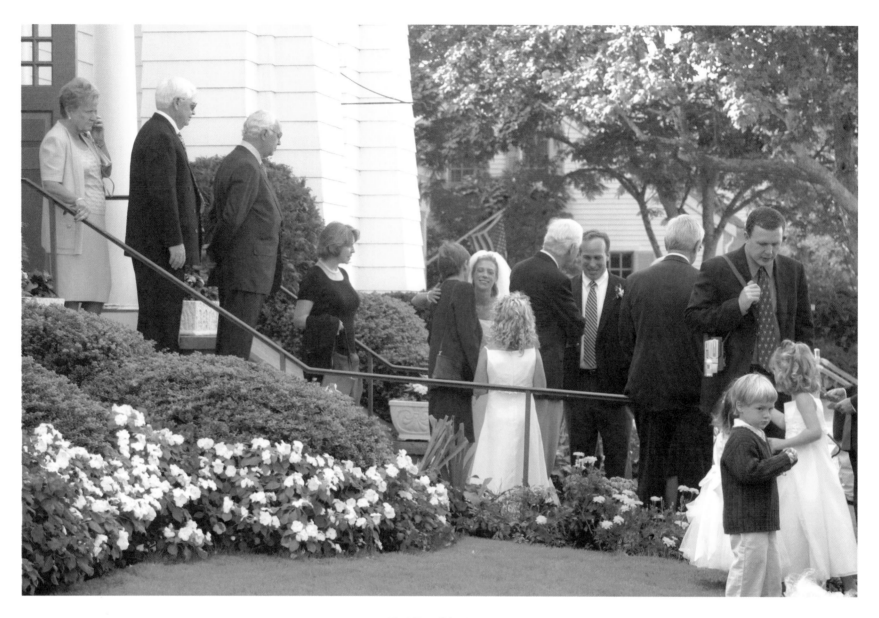

Wedding, Edgartown

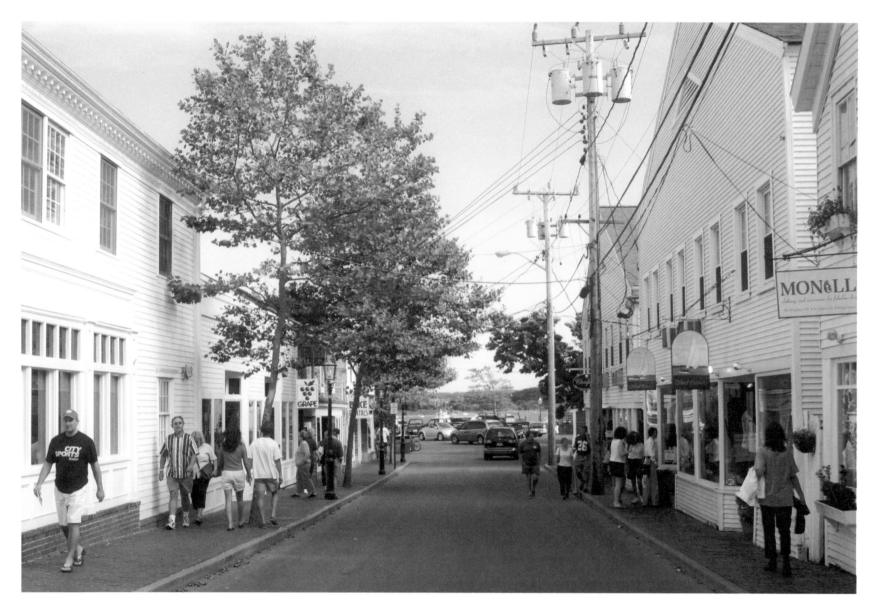

Main Street, Edgartown

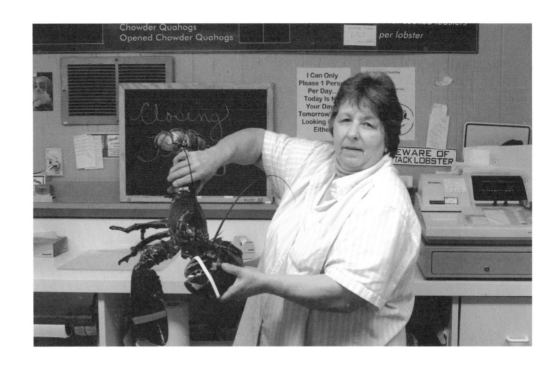

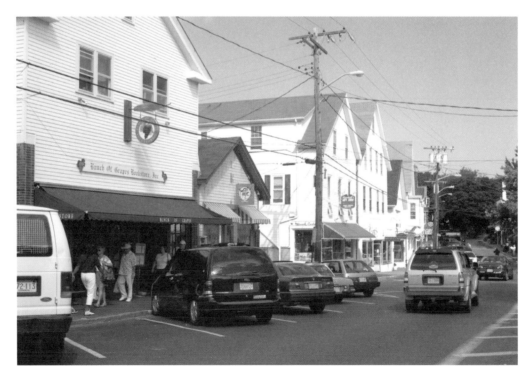

Top: John's Fish Market. Bottom: Main Street, Vineyard Haven.

The Aquinnah Shop on the Cliffs, Aquinnah

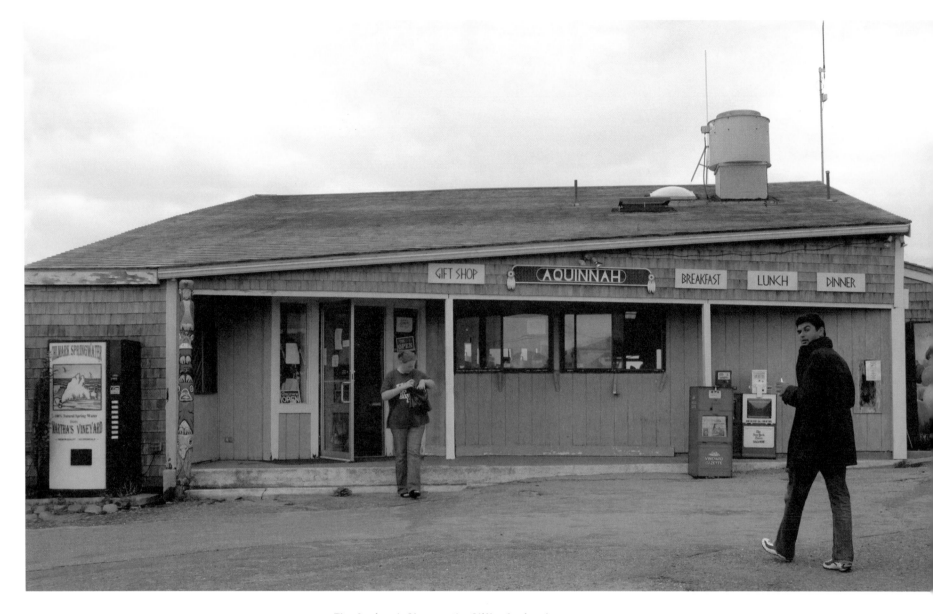

The Aquinnah Shop on the Cliffs, Aquinnah

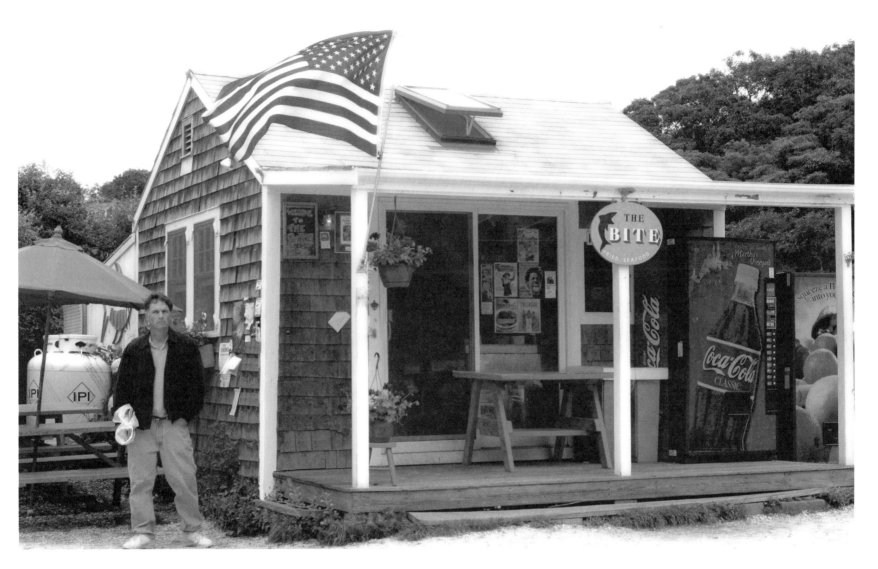

The Bite, Basin Road, Menemsha

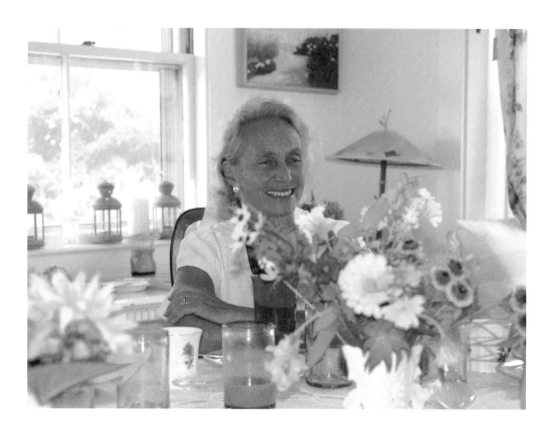

A literary lunch, Vineyard Haven

Guest cottage, Chip Chop, Tisbury

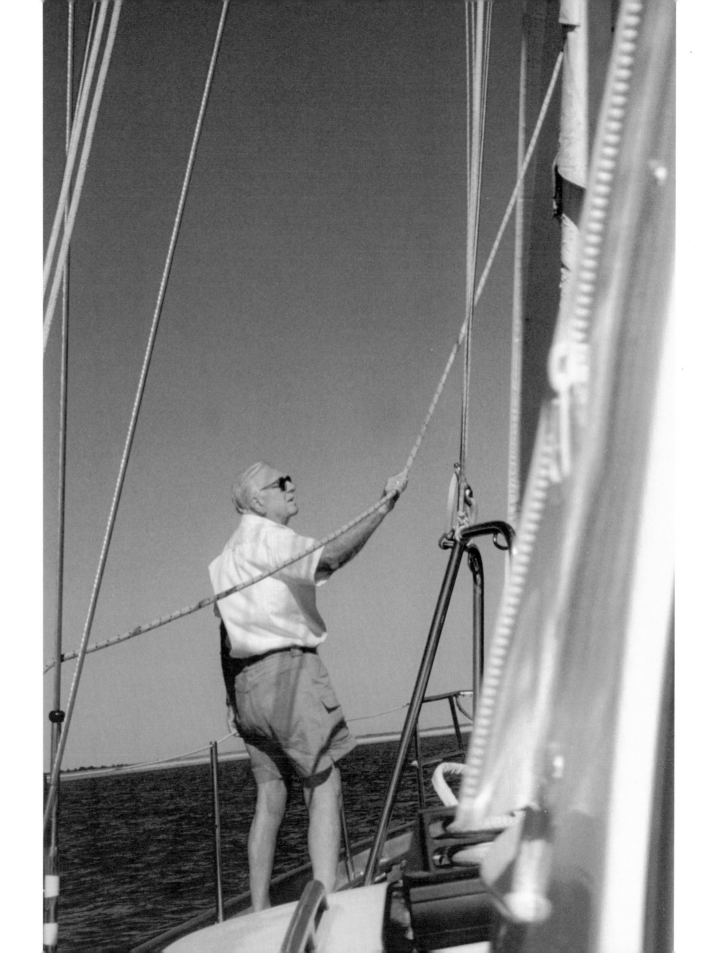

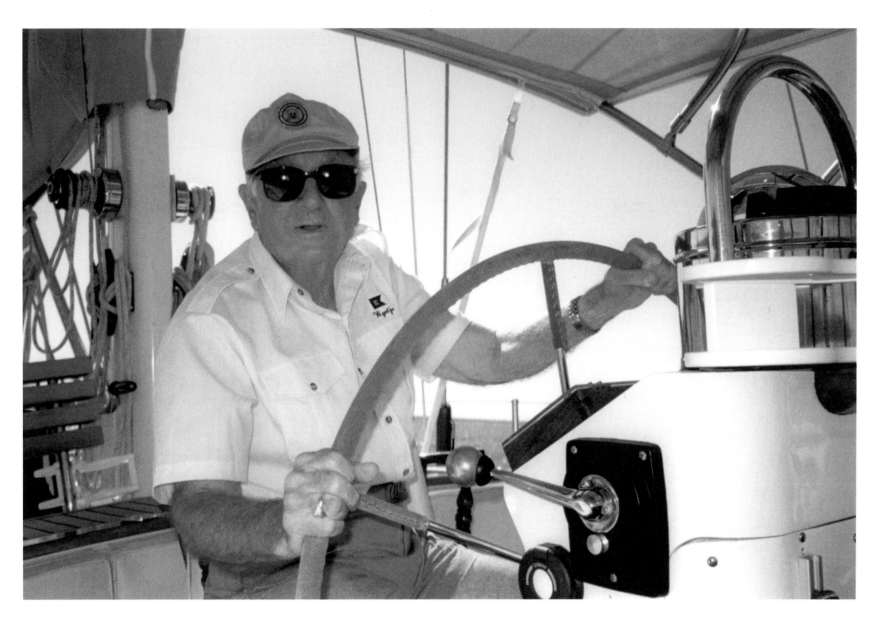

On board the *Wyntje*

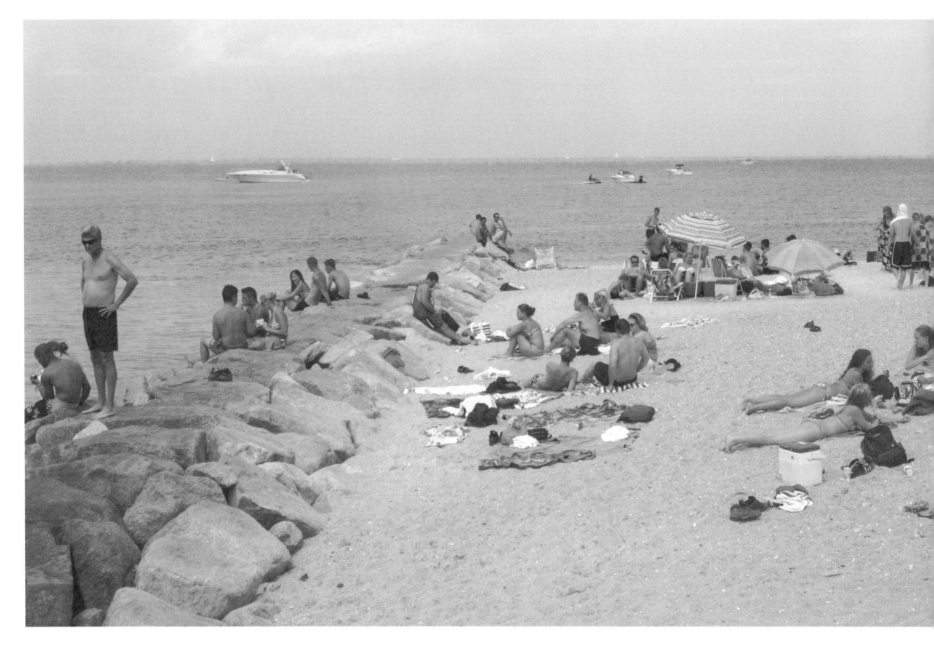

State Beach, Edgartown

Oak Bluffs

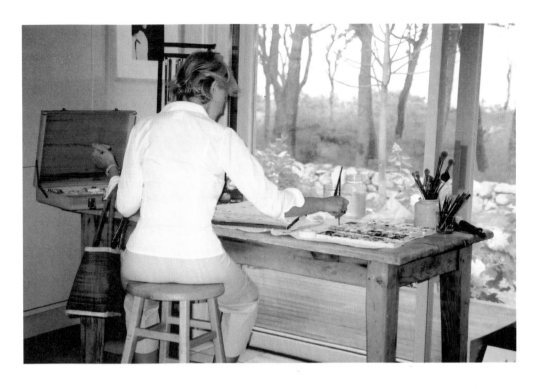

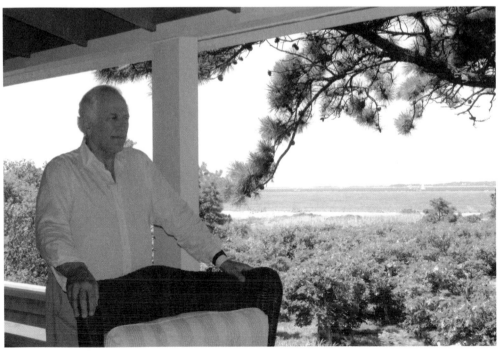

Top: Watercolorist with handbag. Bottom: The luncheon host.

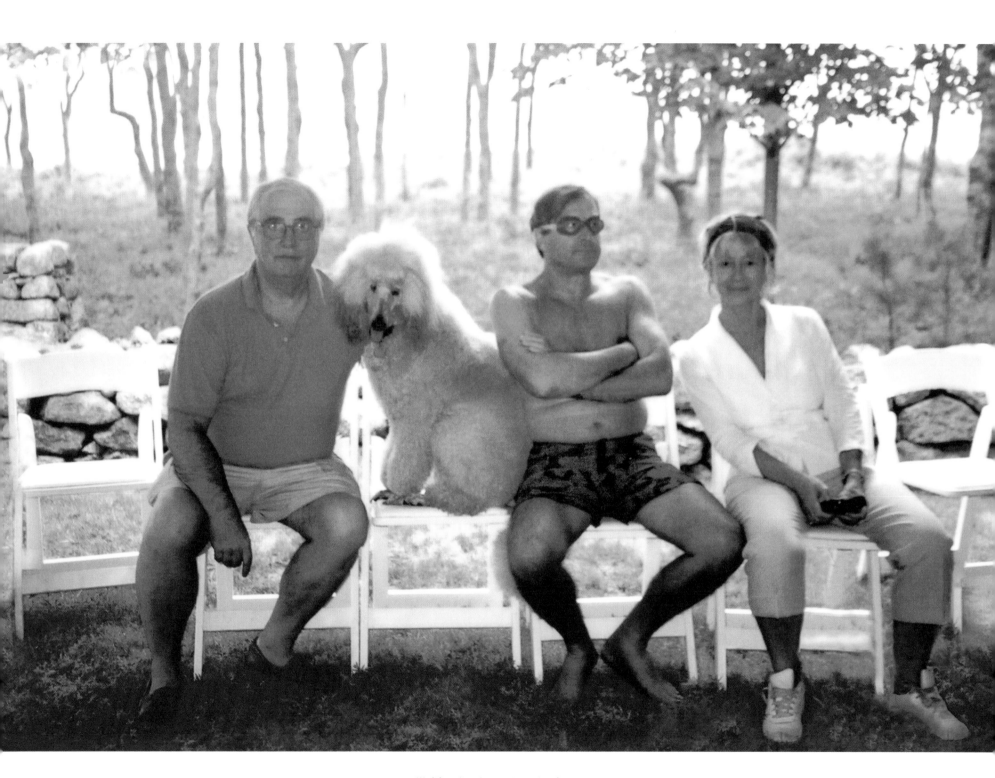

Waiting for the party to begin

AFTERNOON

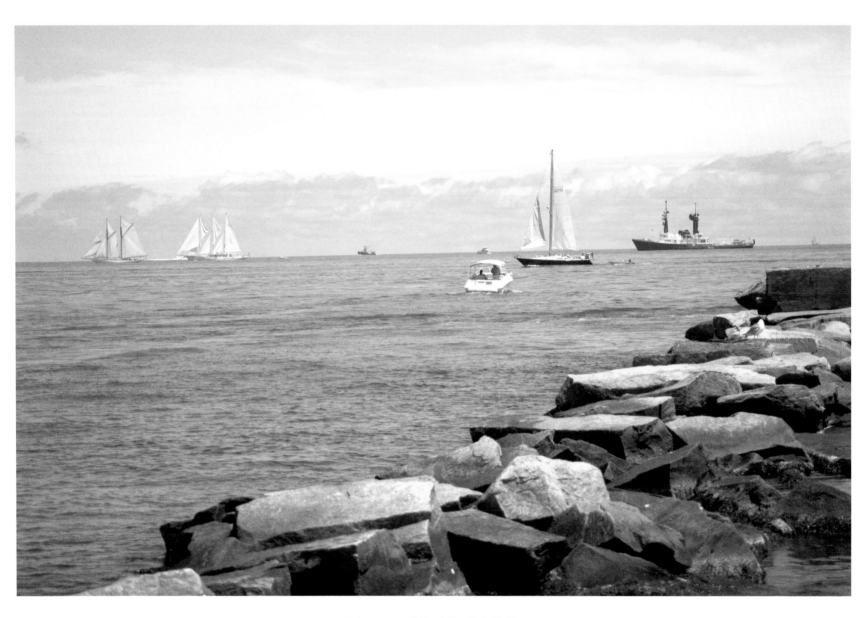

Schooners off the jetty, Oak Bluffs

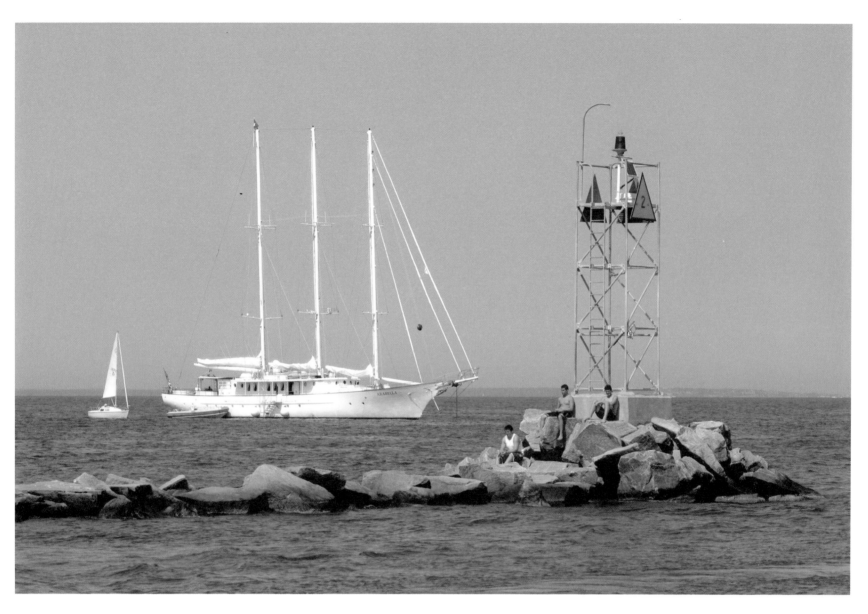

At anchor, Oak Bluffs

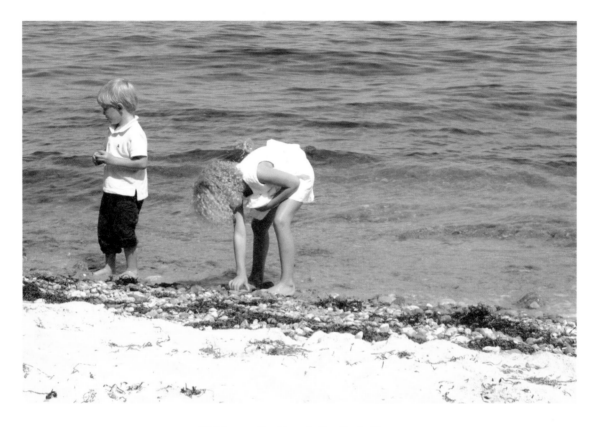

Children collecting shells, North Shore

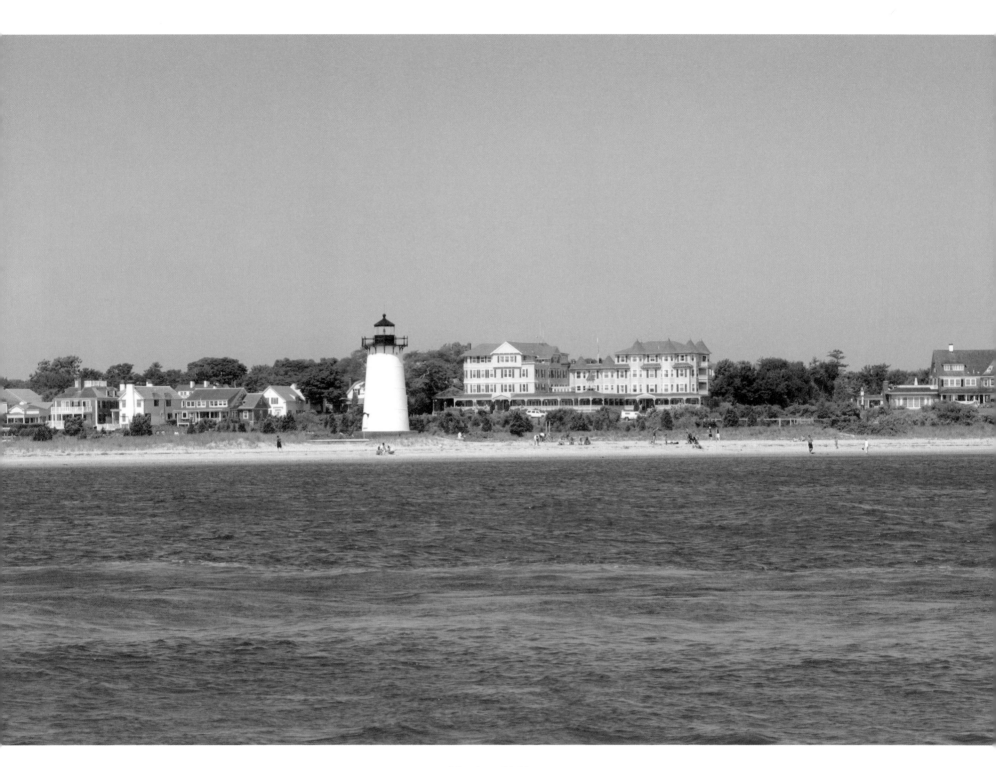

Edgartown Light

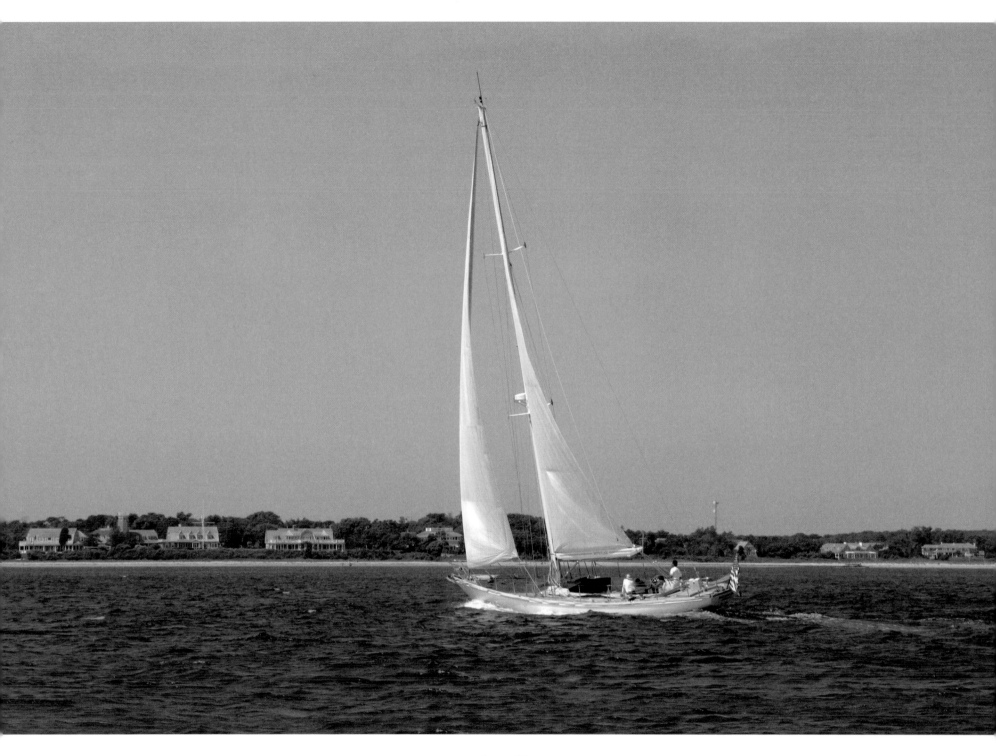

Day-sailing

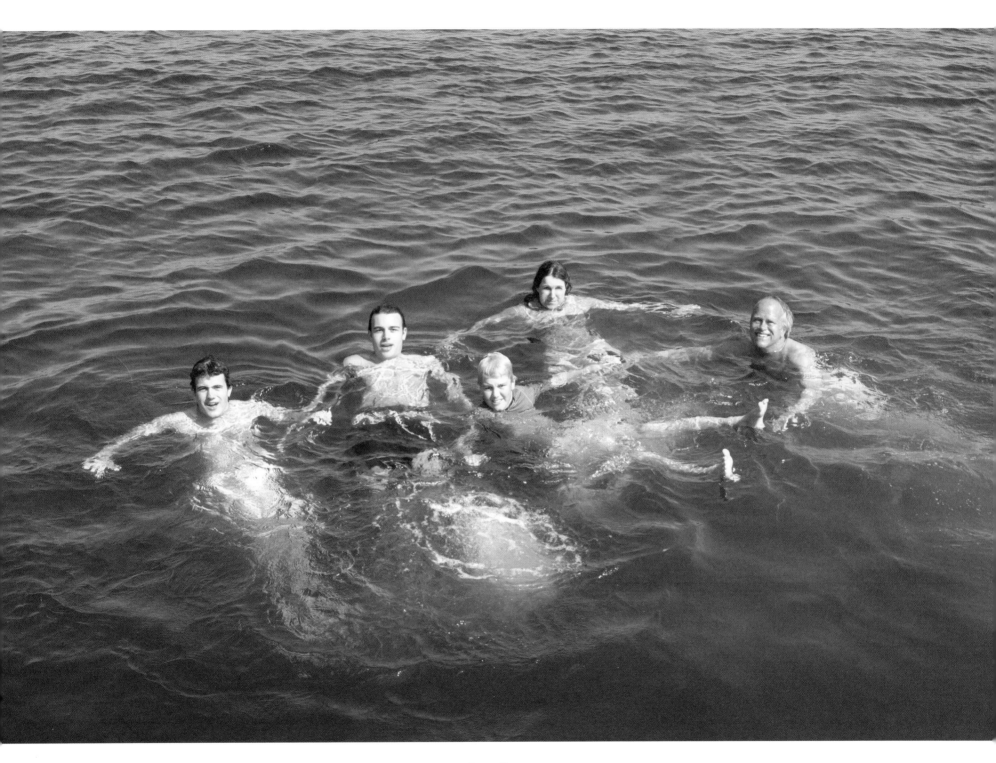

Noon dip

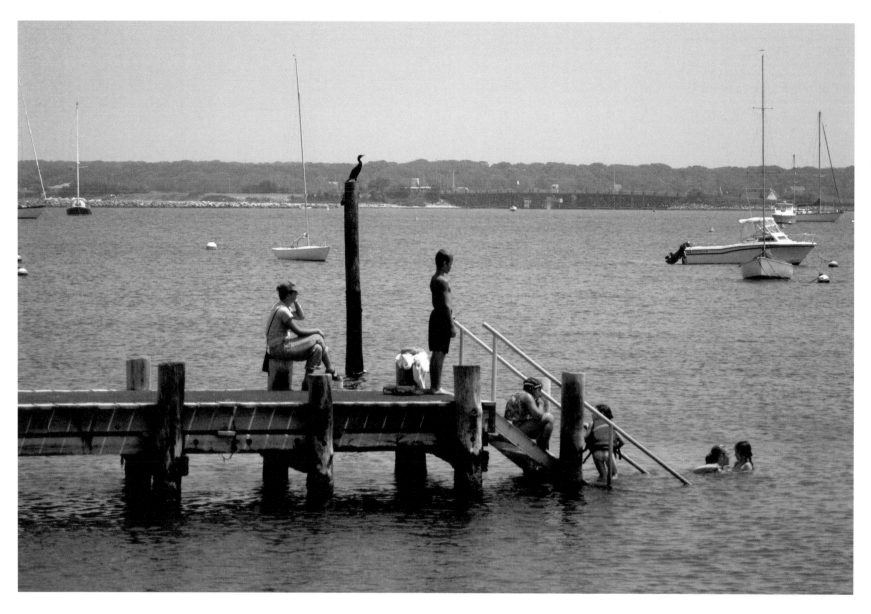

Vineyard Haven Yacht Club

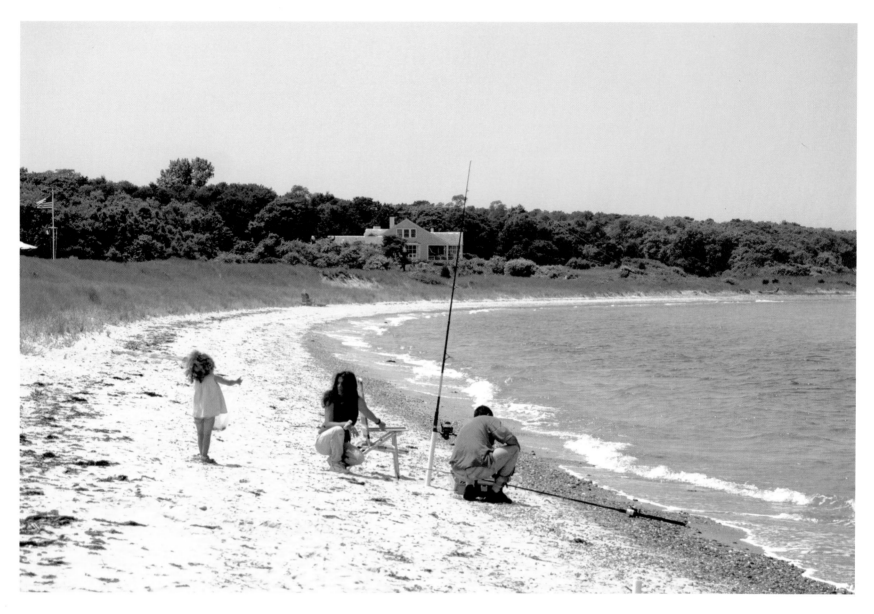

Fishing, North Shore

Morning Glory Farm, Edgartown

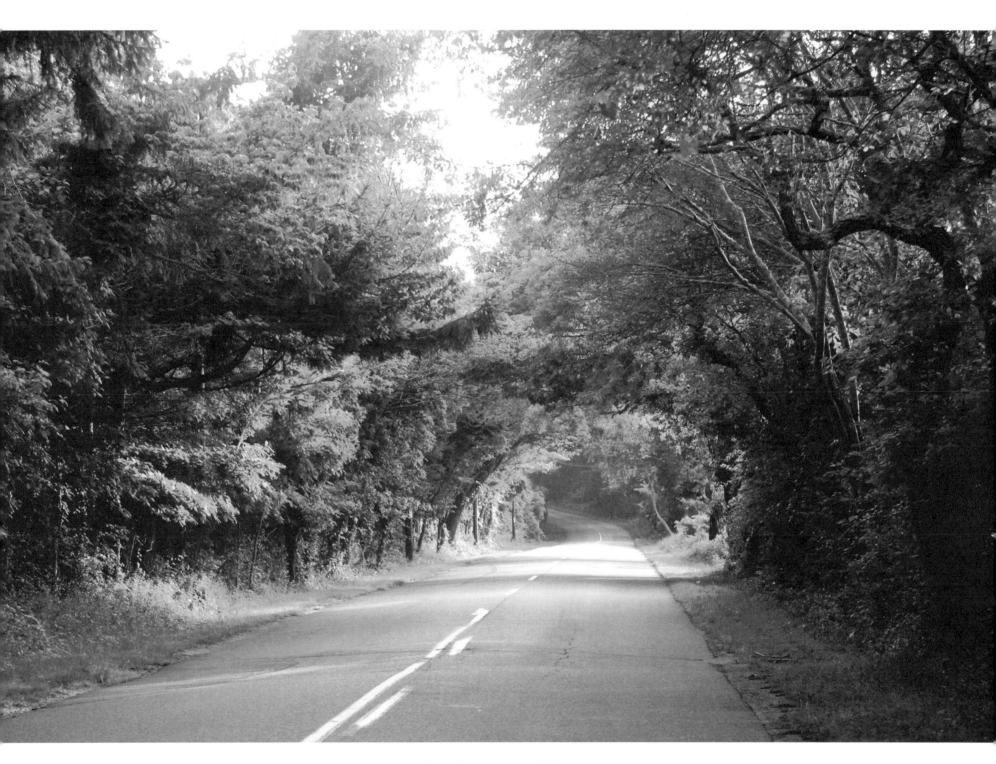

North Road to Menemsha, Chilmark

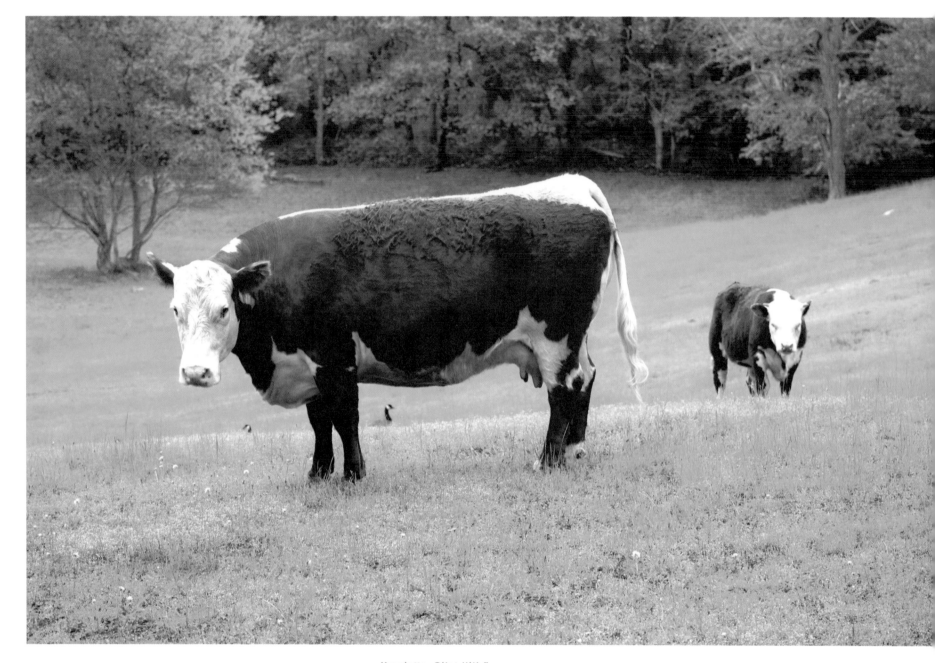

Henrietta, Pilot Hill Farm

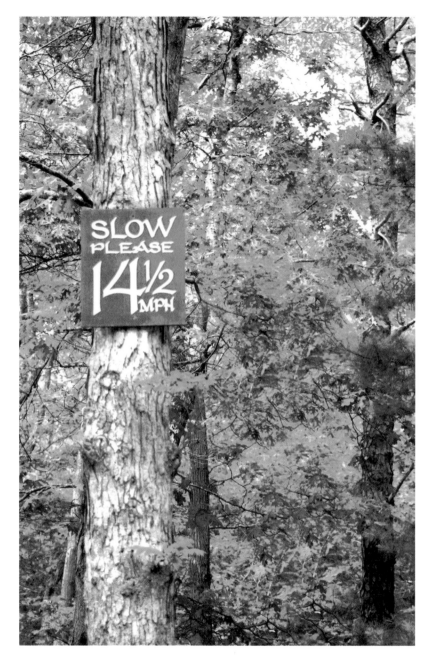

Speed limit, Tisbury.

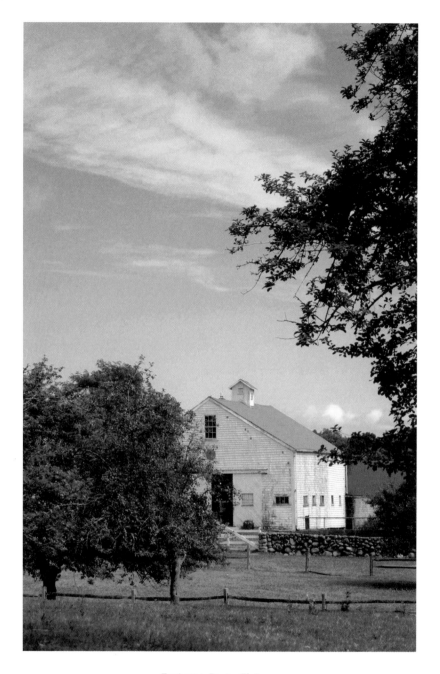

Tashmoo Farm, Tisbury

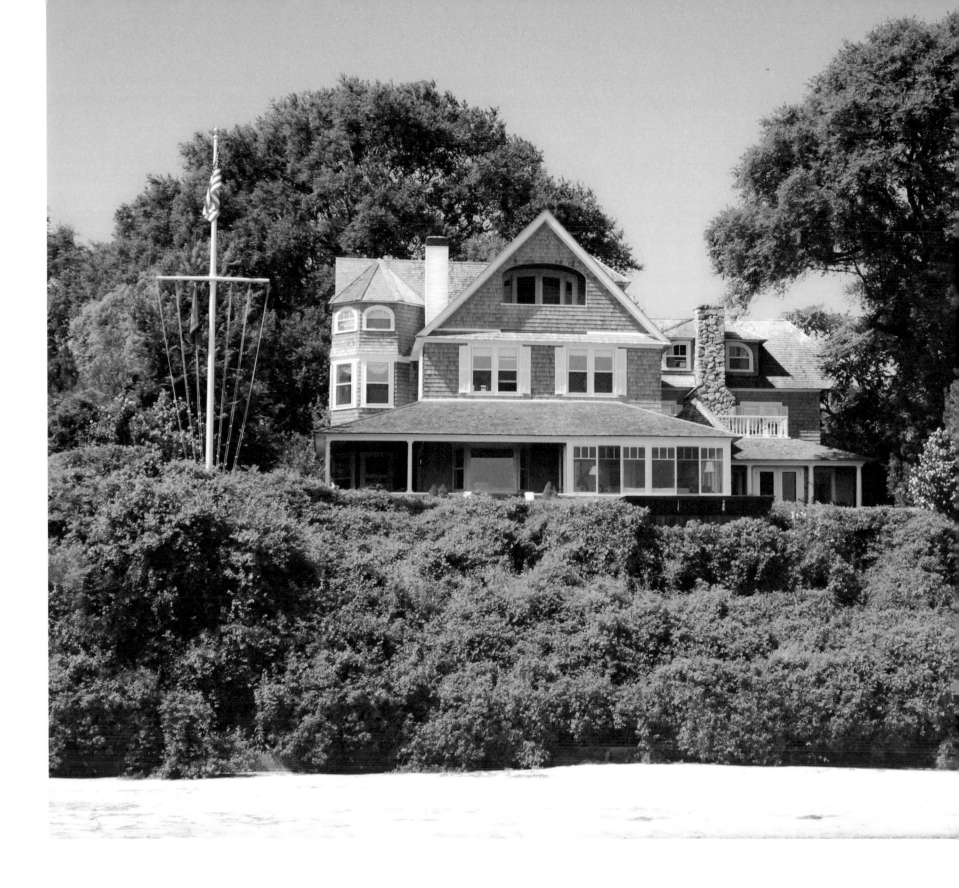

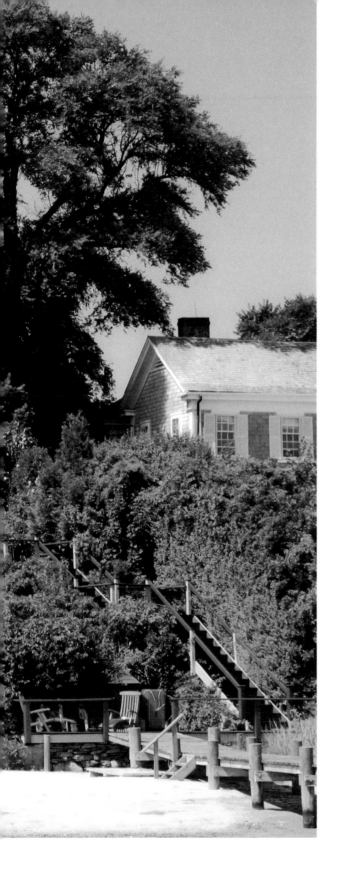

Daybreak, Edgartown

Seth's Pond

Fishing Herring Creek, Lake Tashmoo

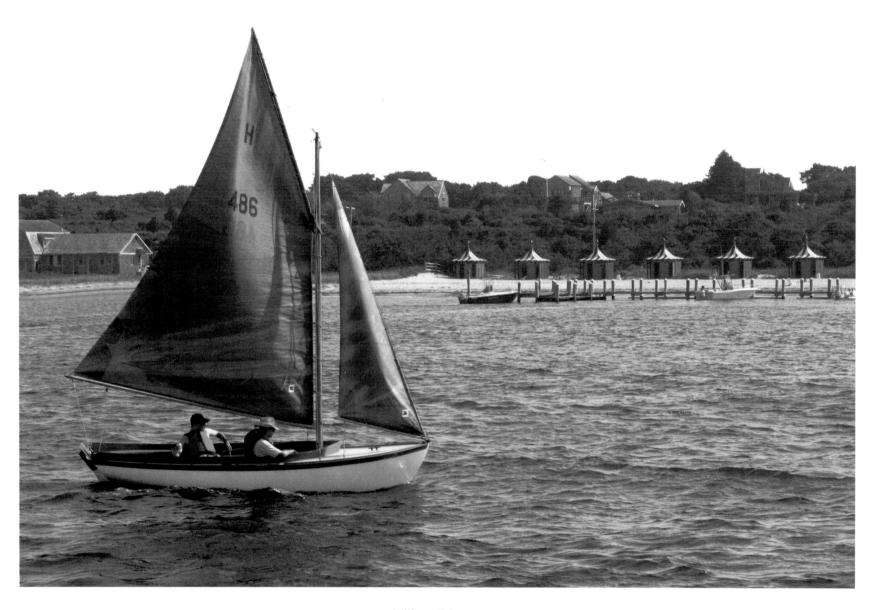

Sailing off Chappy

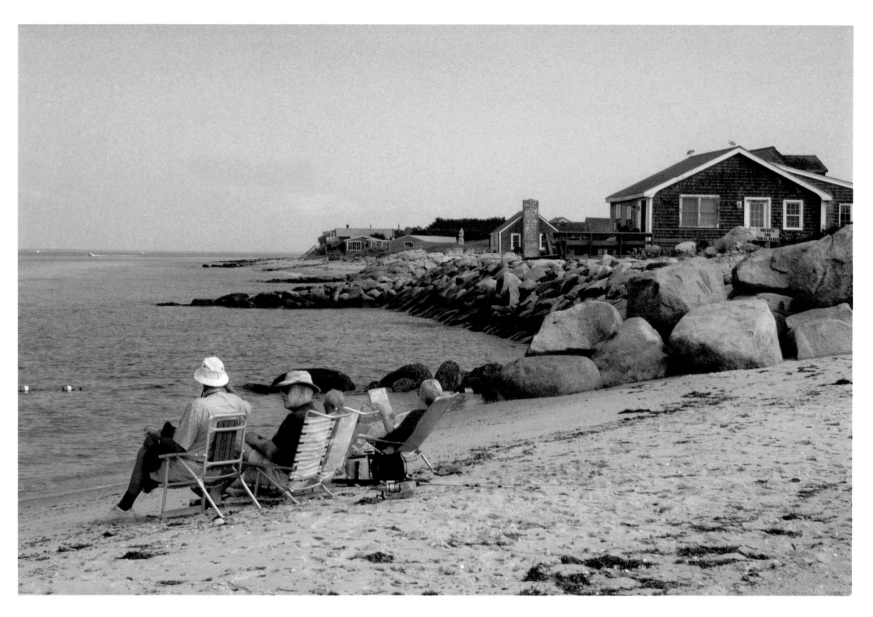

Lake Tashmoo Town Beach, Vineyard Haven

Inkwell Beach, Oak Bluffs

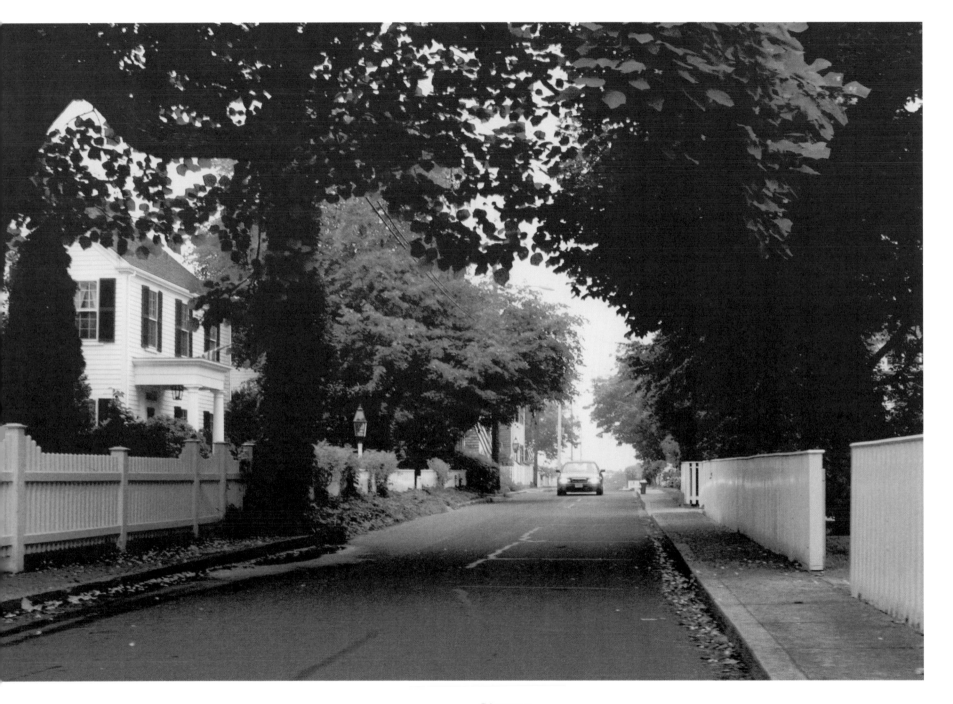

Edgartown

Parked on Main Street

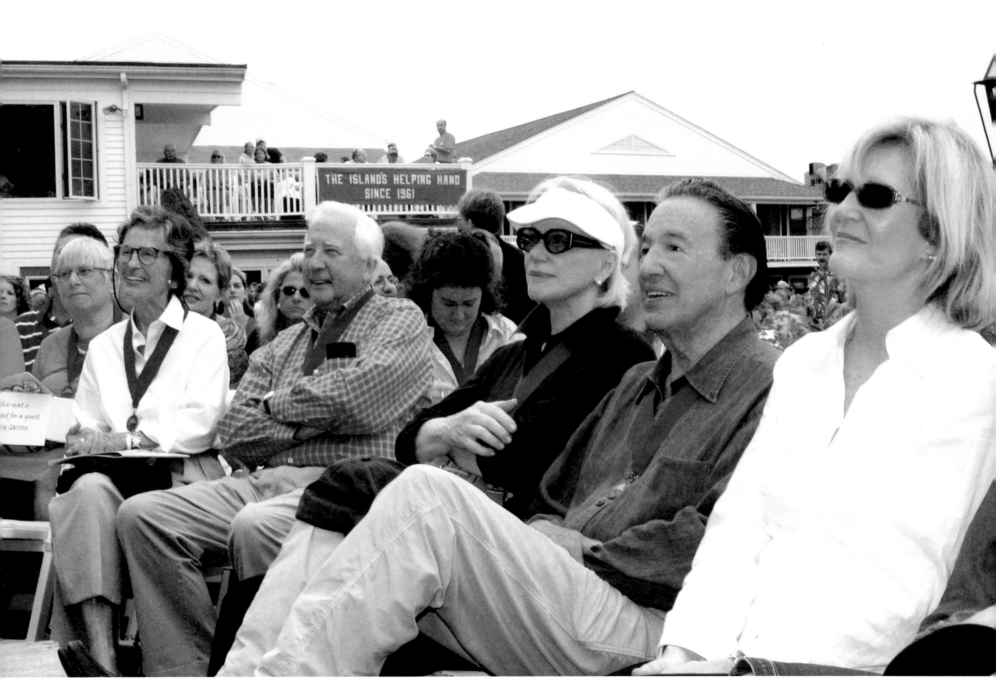

Possible Dreams Auction, Edgartown

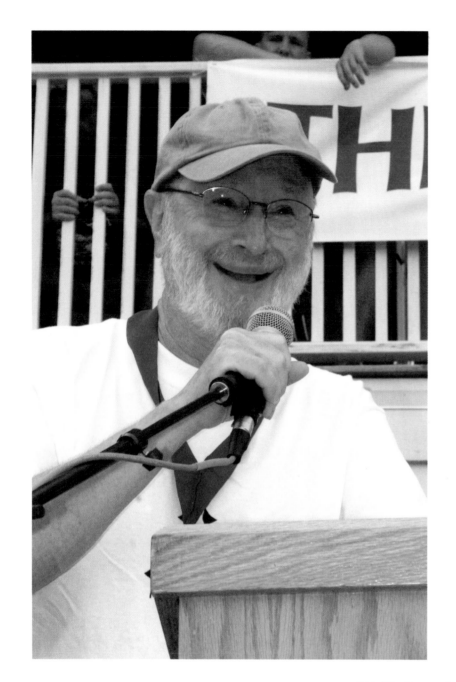

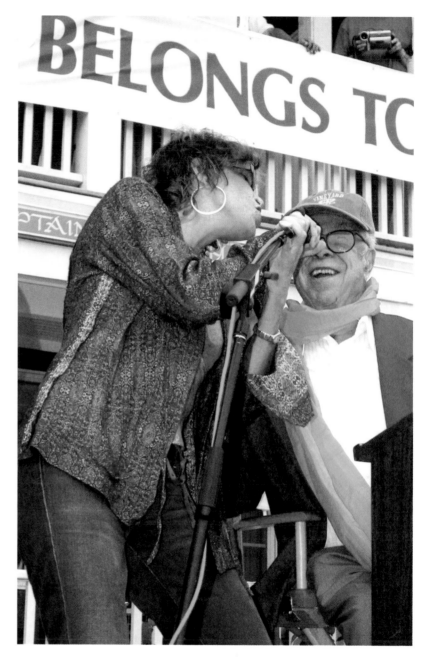

Possible Dreams Auction, Edgartown

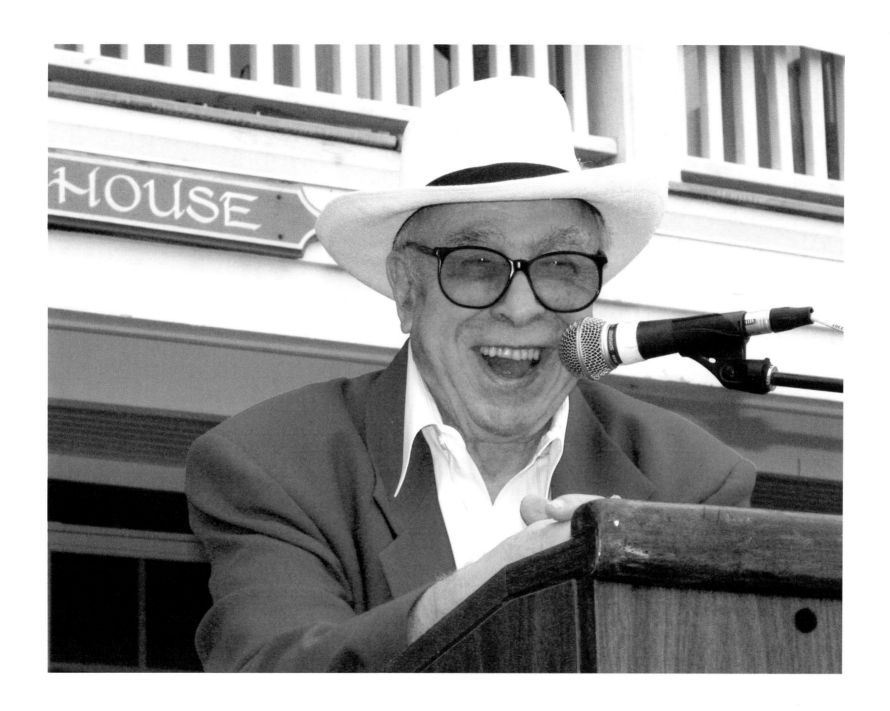

Moshup Beach, Aquinnah

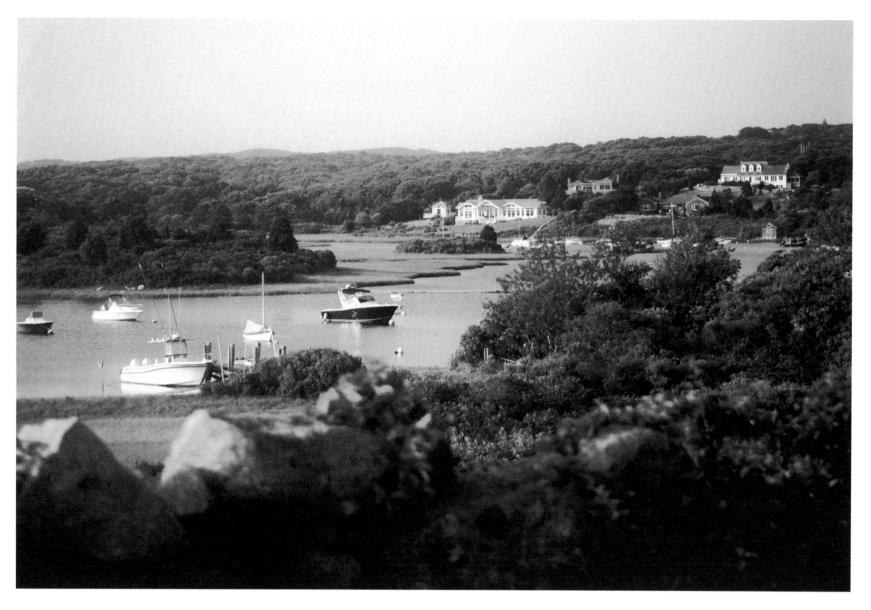

Quitsa Pond, Chilmark

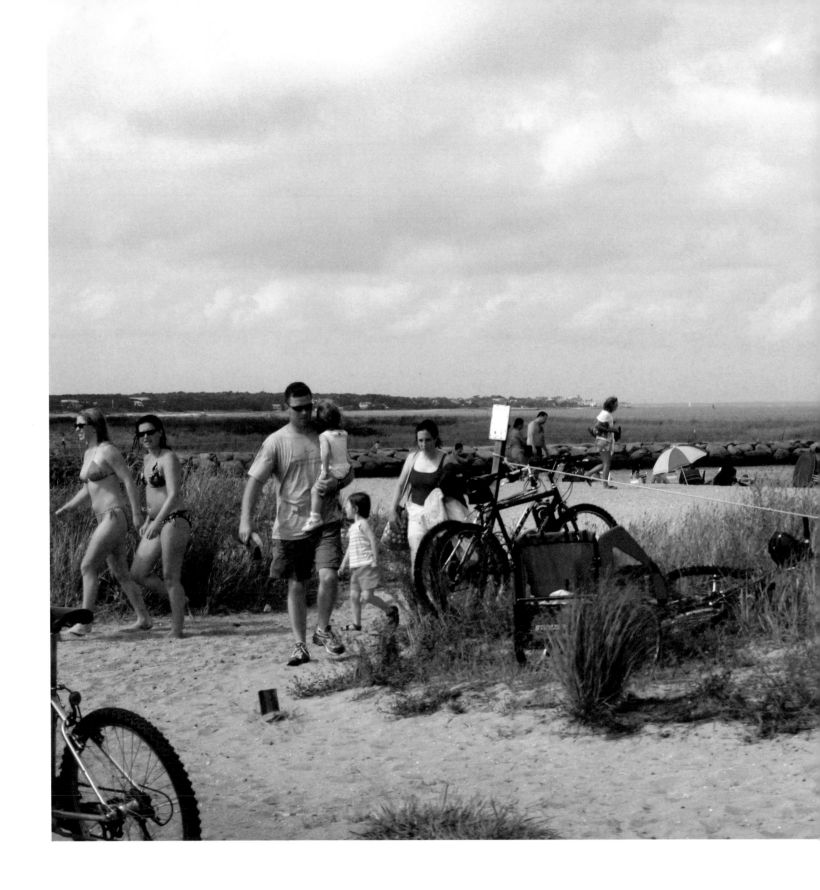

End of day, State Beach, Edgartown

Sails drying, Vineyard Haven Yacht Club

124

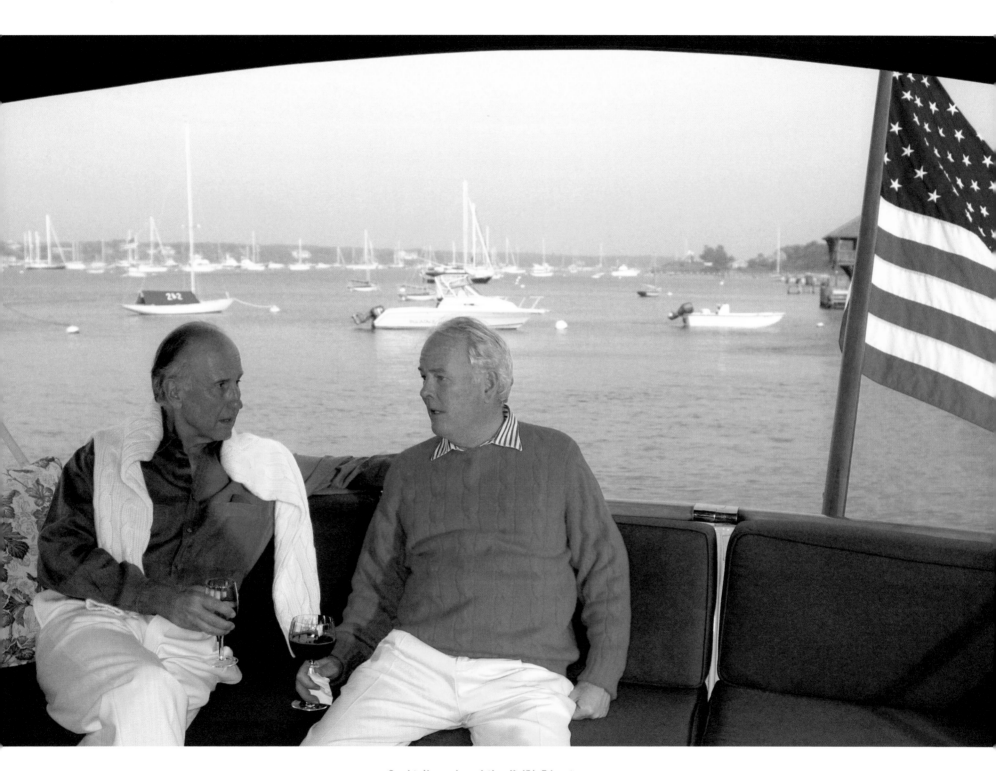

Cocktails on board the *KelDi*, Edgartown

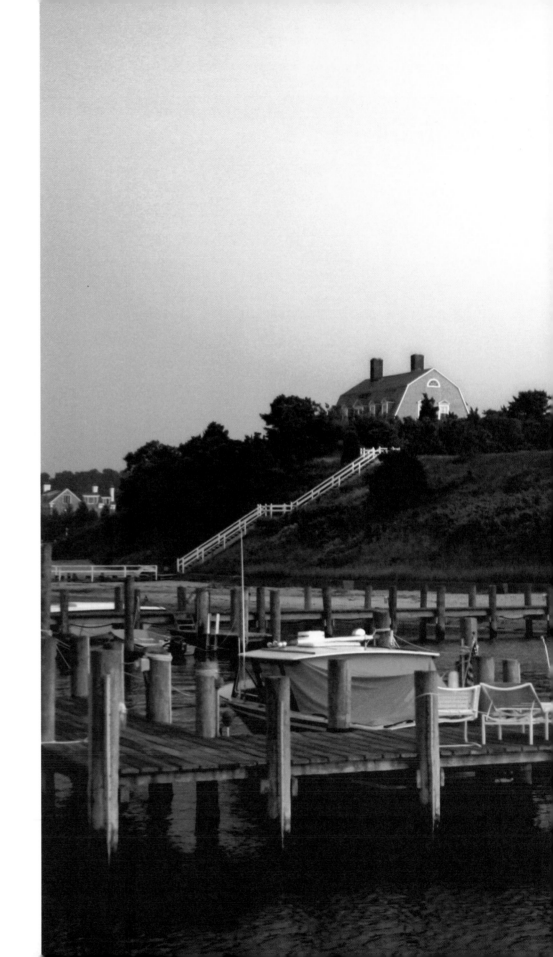

Tower Hill, Edgartown

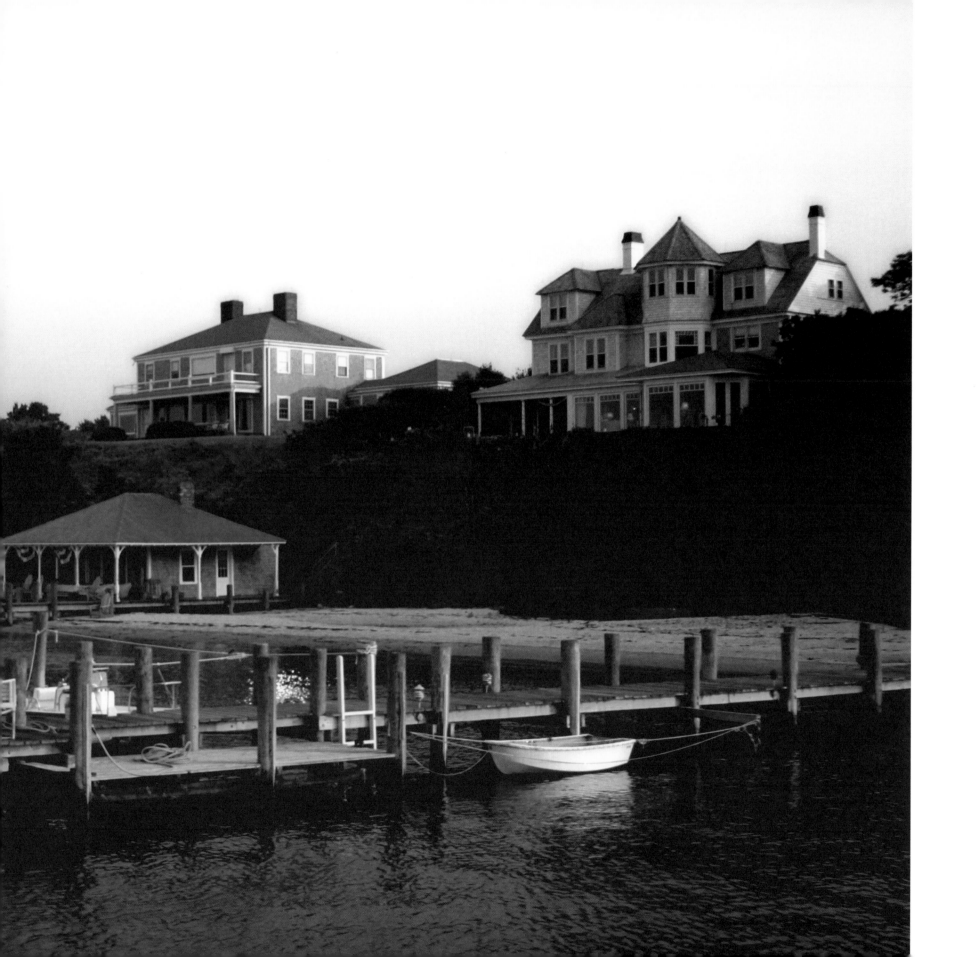

Below the Cliffs, North Shore, Aquinnah

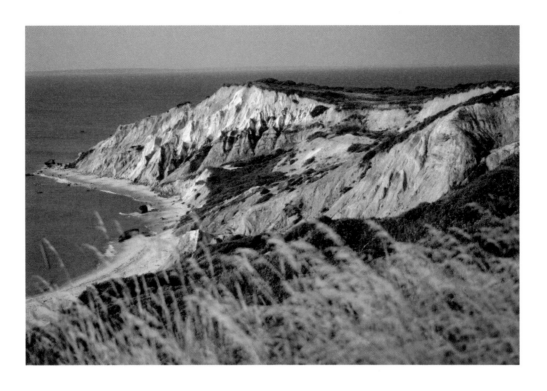

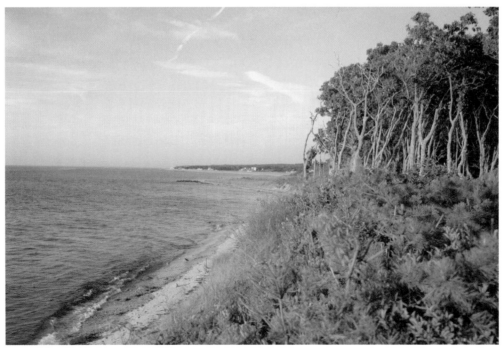

Top: The Gay Head Cliffs, Aquinnah. Bottom: Scrub Oaks, The North Shore.

Menemsha Harbor

130

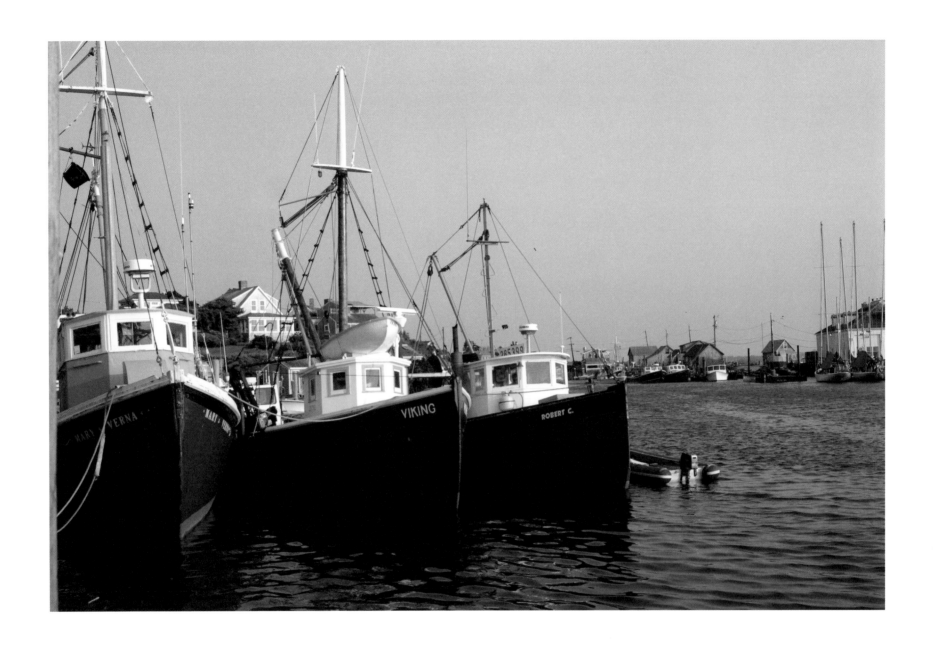

Top: Buoys. Bottom: Crates.

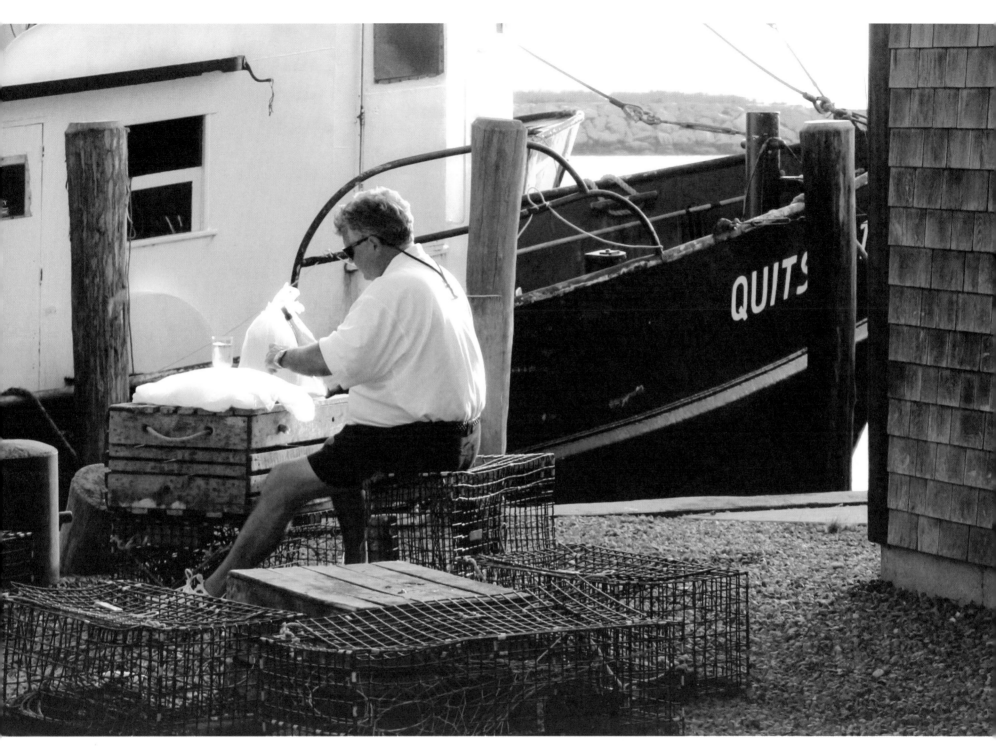

Alfresco dining, Menemsha

The 7:00 P.M. screening, Vineyard Haven

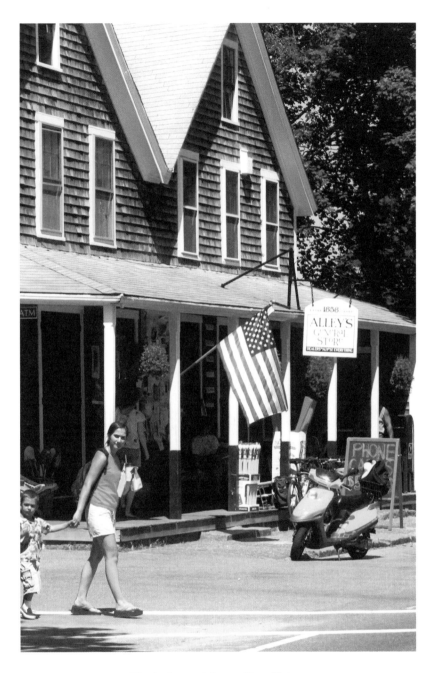

Alley's General Store, West Tisbury

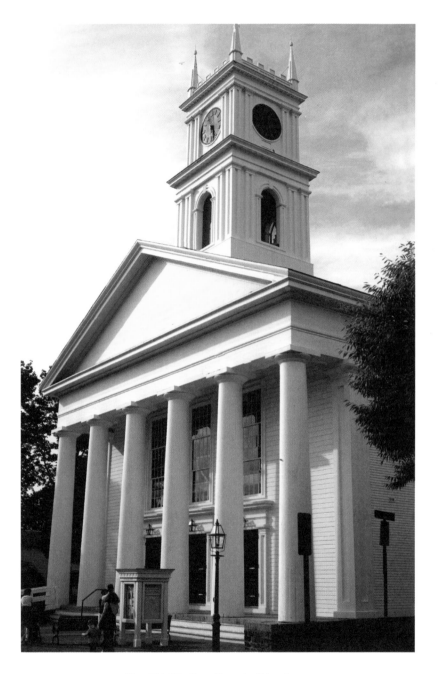

The Old Whaling Church, Edgartown

Stone wall, North Shore

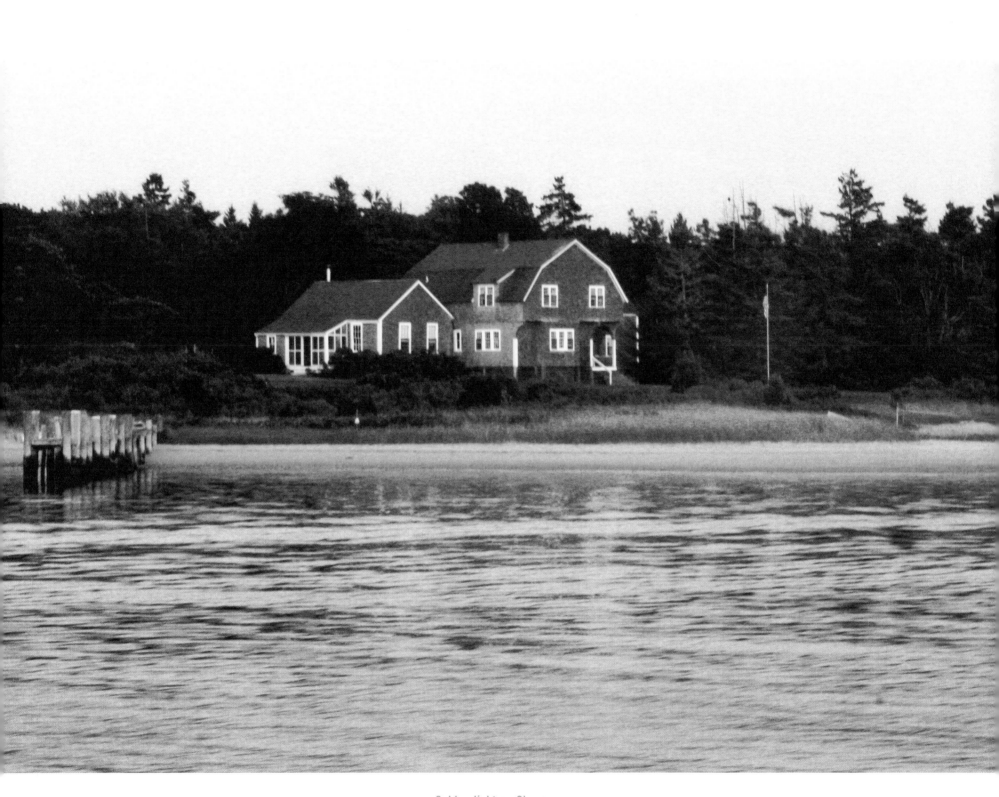

Golden light on Chappy

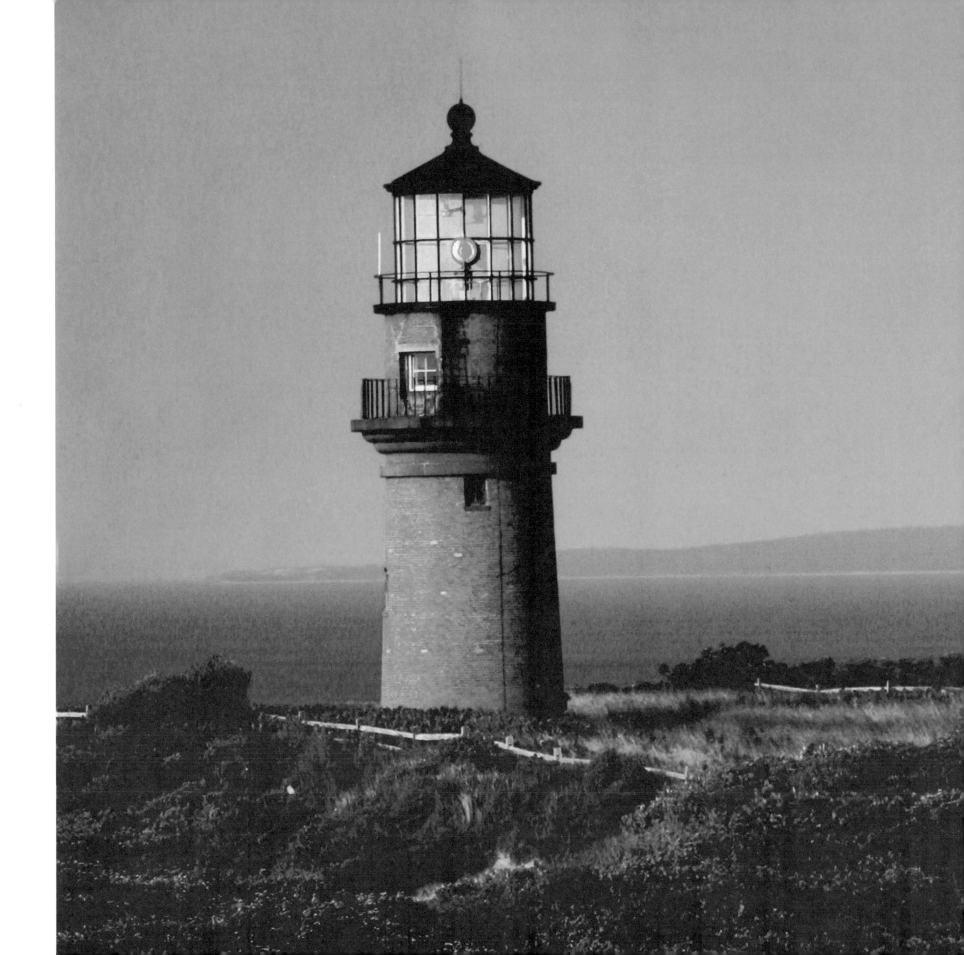

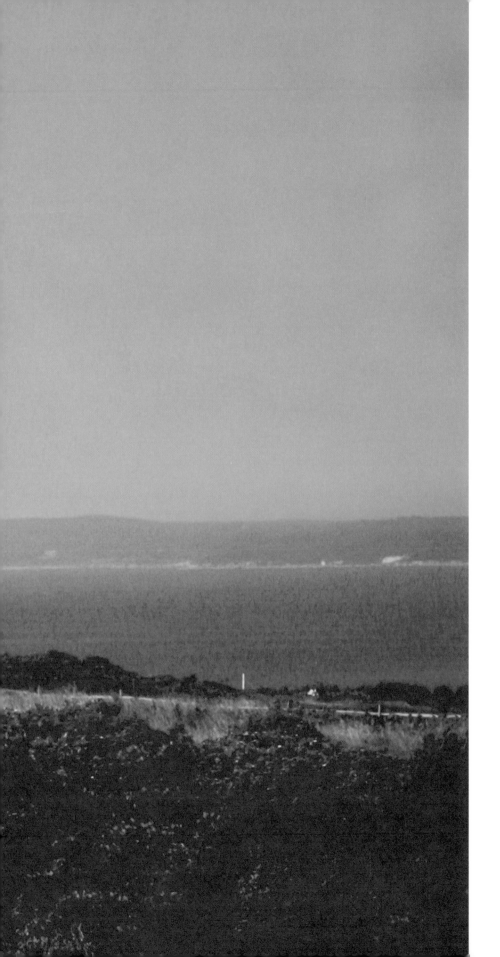

Gay Head Light, Aquinnah

139

EVENING

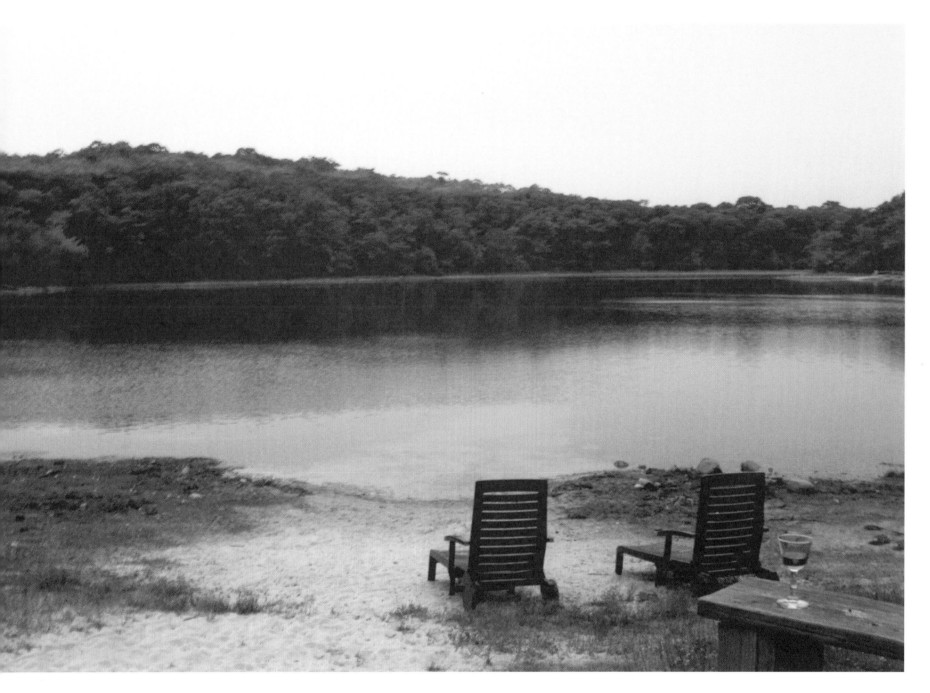

Ice House Pond, West Tisbury

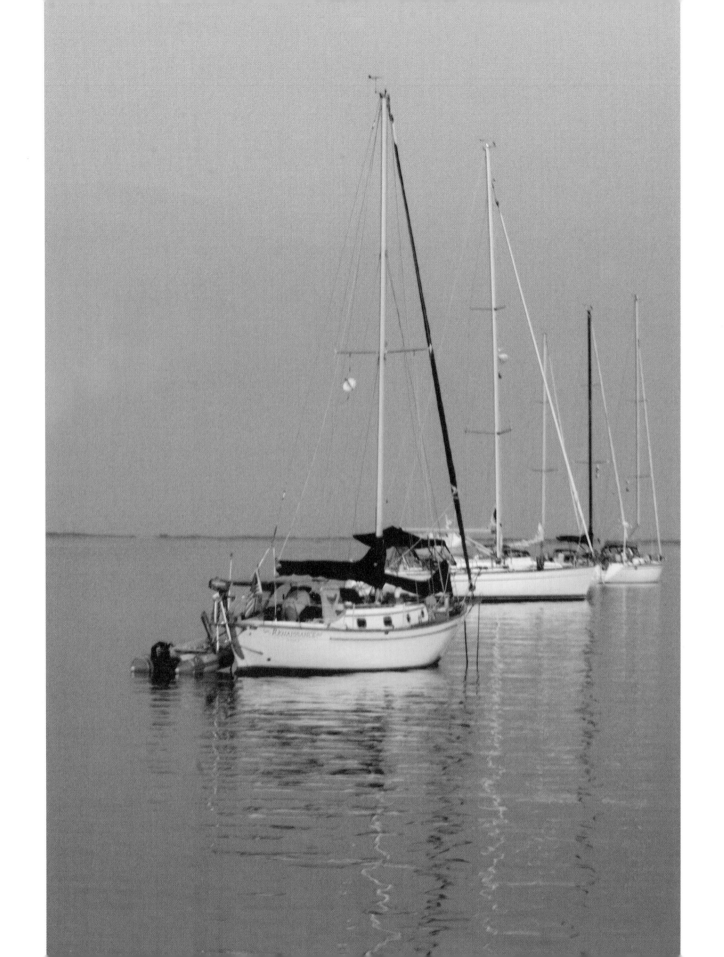

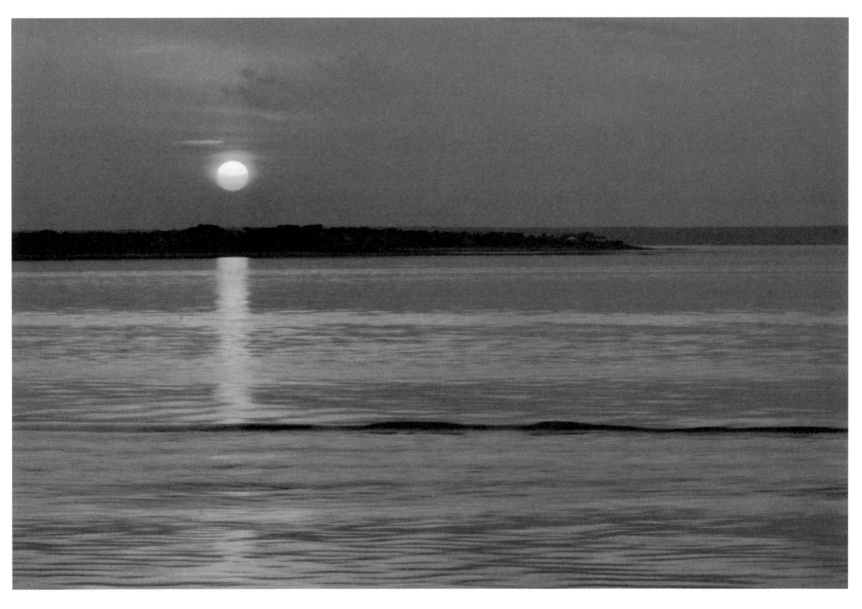

Katama Bay, Edgartown

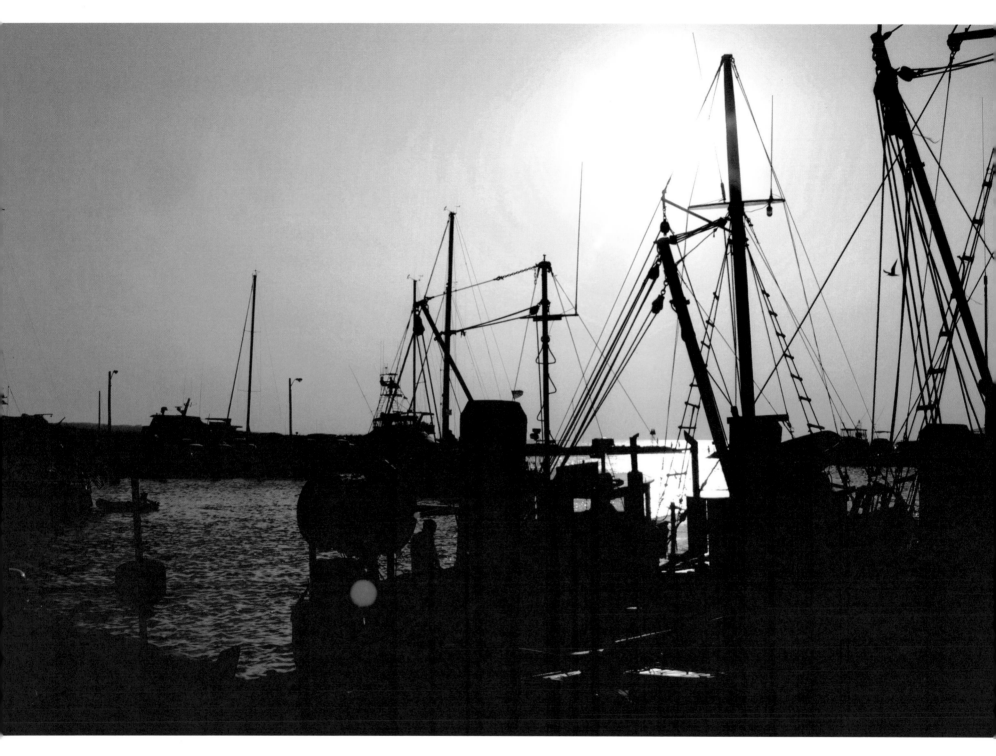

Menemsha Harbor

North Shore sunset

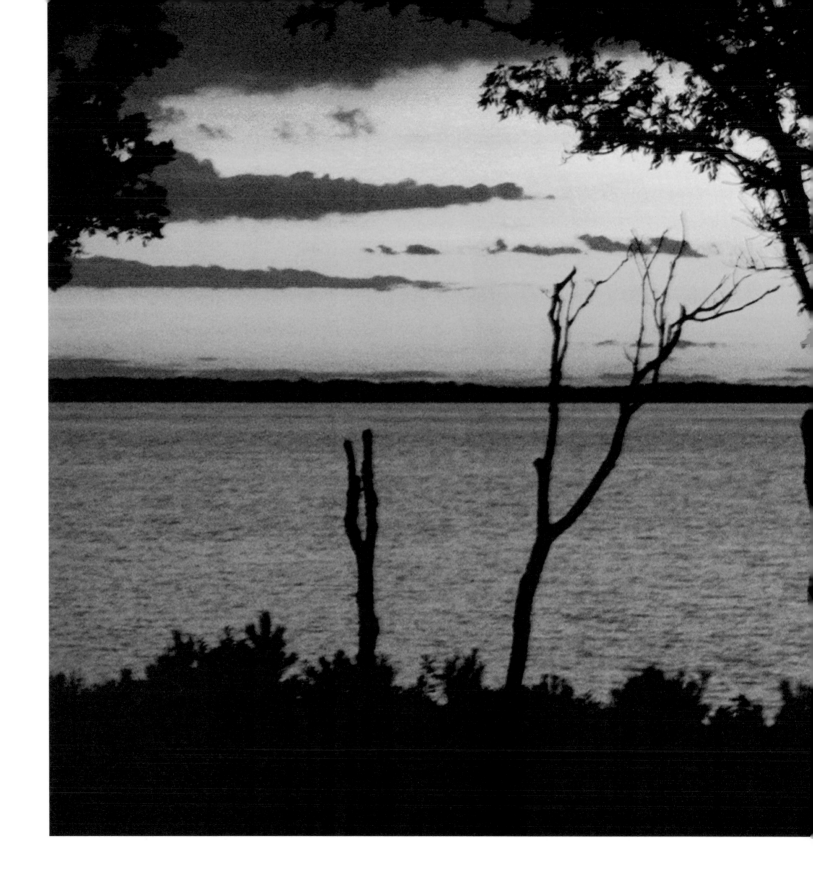

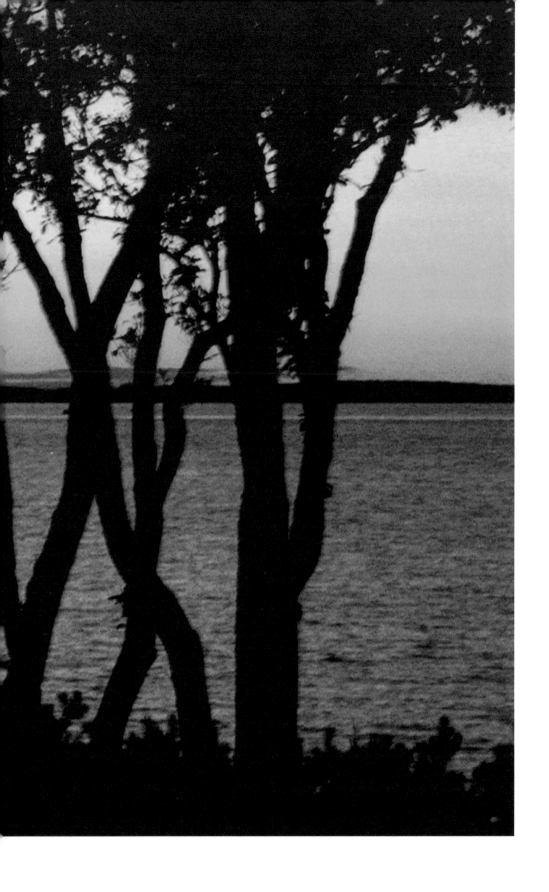

Towards Woods Hole and the Elizabeth Islands, North Shore

Lake Tashmoo

150

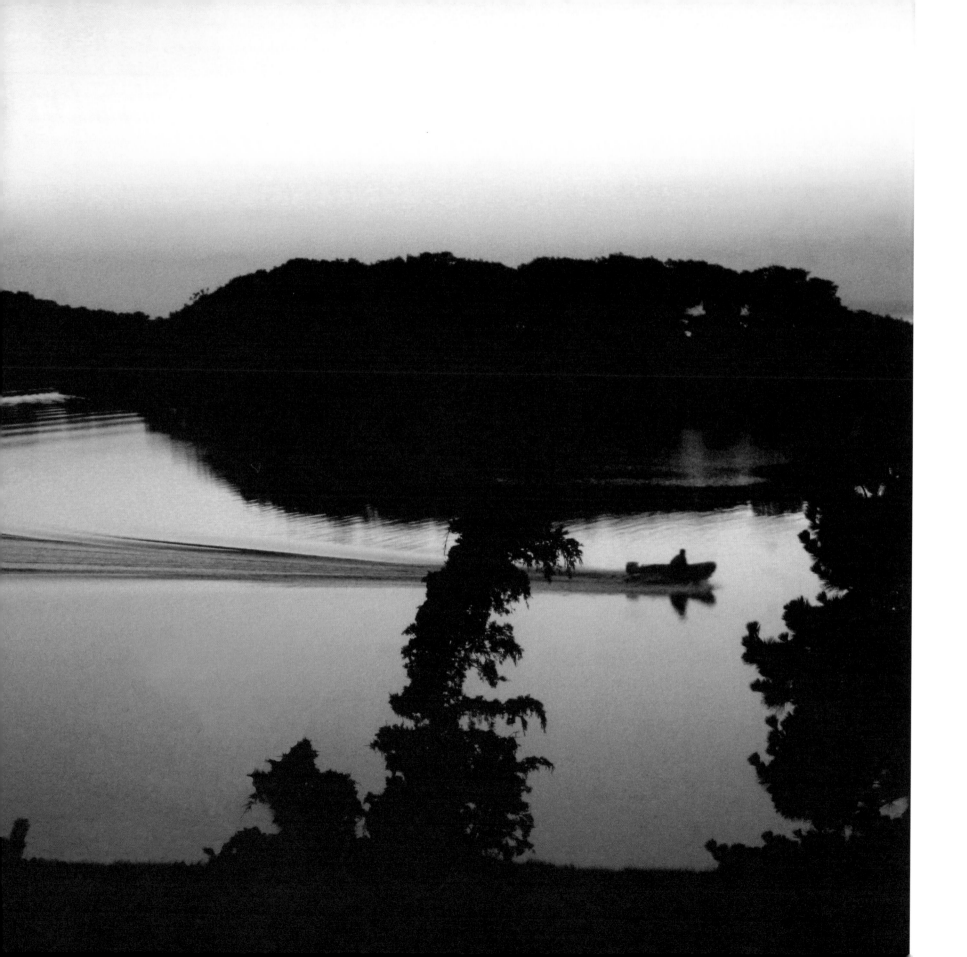

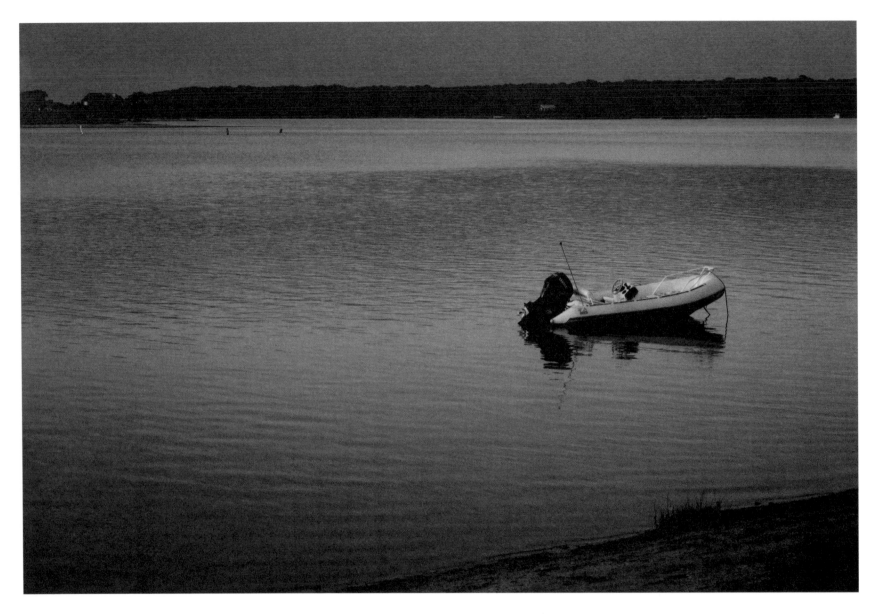

Lake Tashmoo

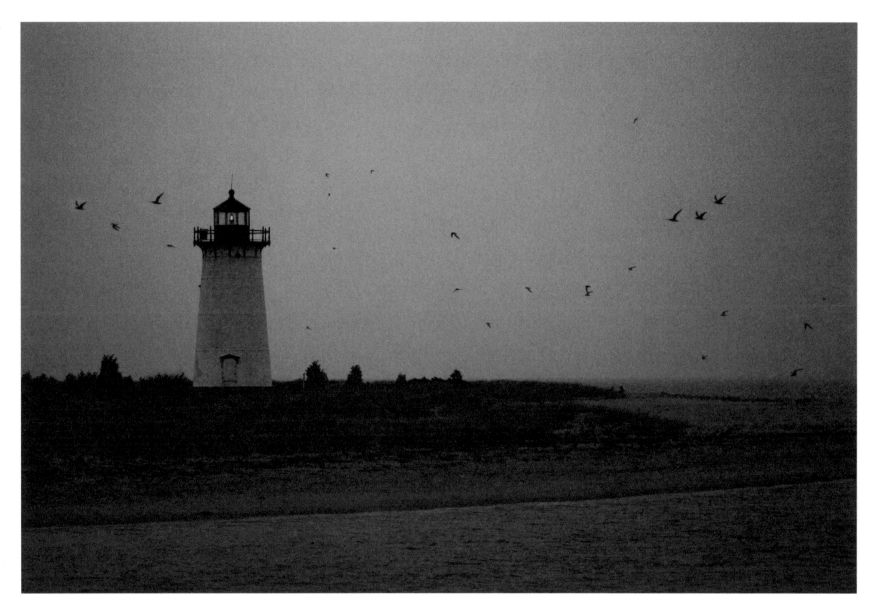

Edgartown Light

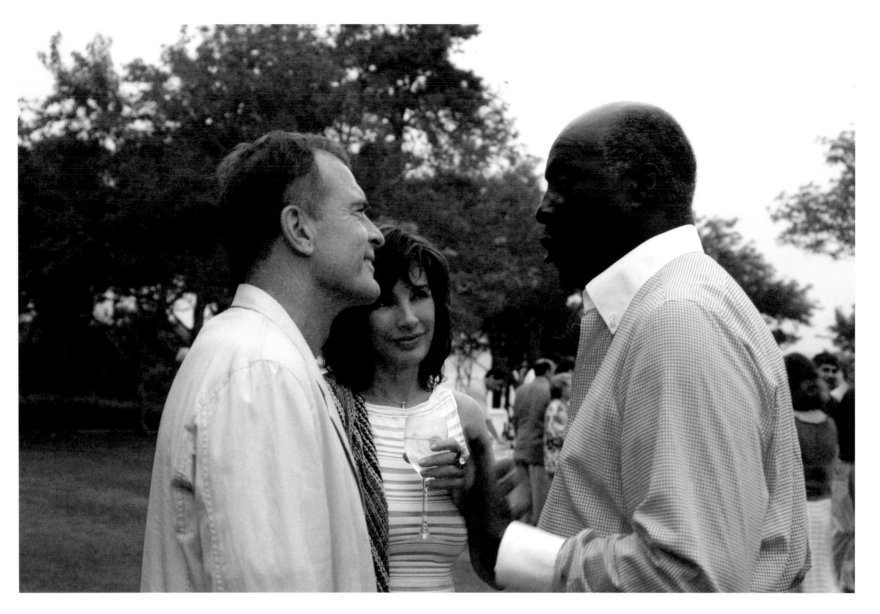

Book party, Edgartown

154

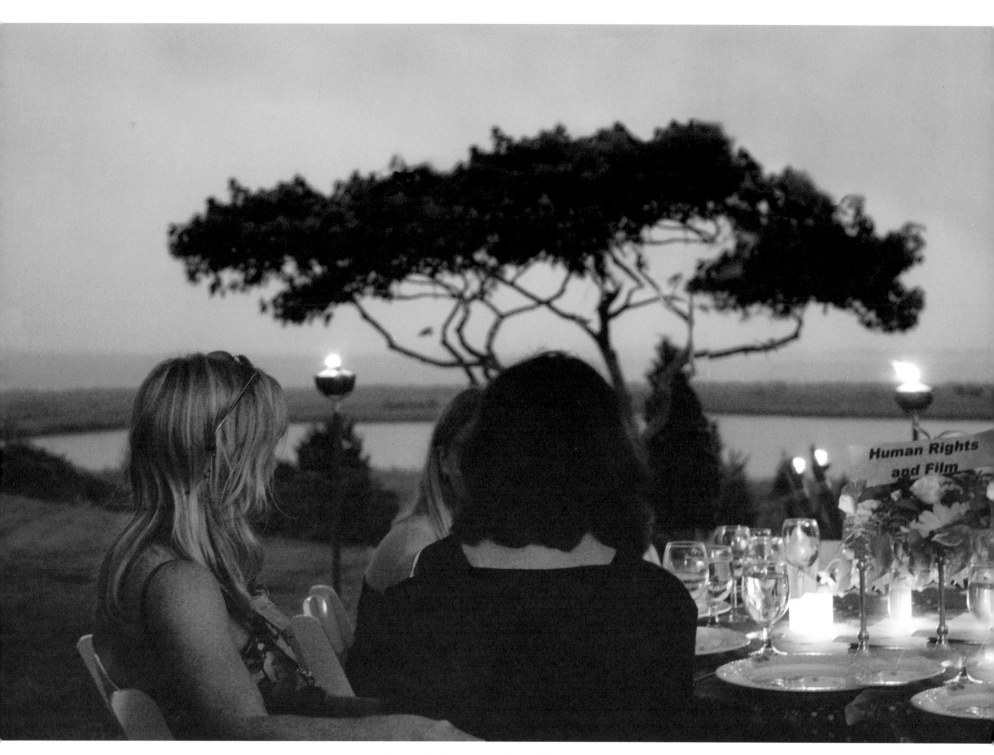

Human Rights Awards dinner, Edgartown

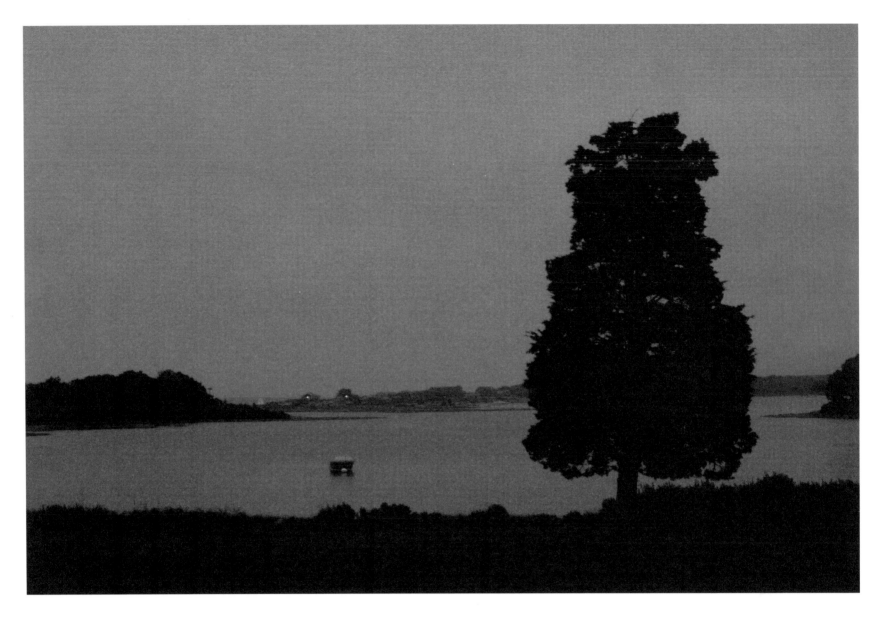

Lake Tashmoo

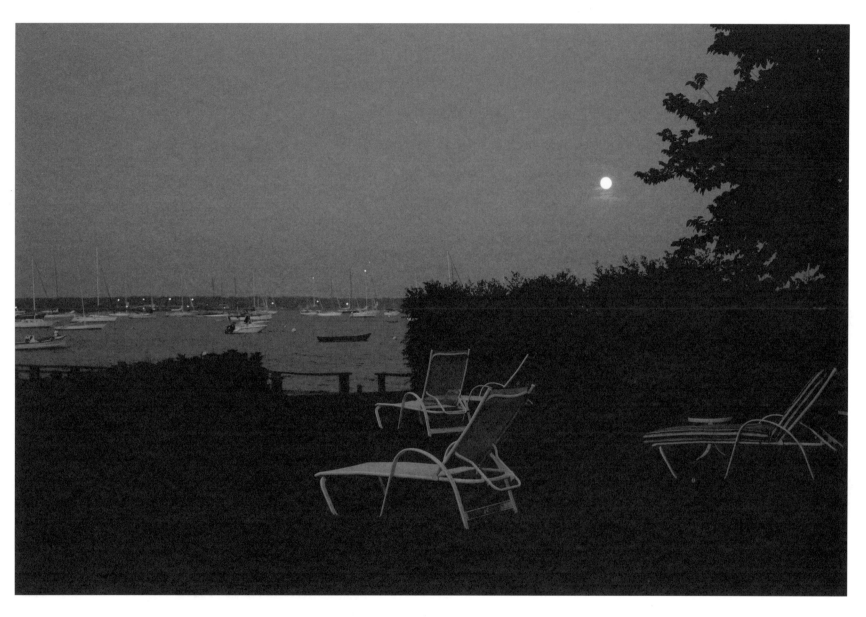

Moon over Vineyard Haven Harbor

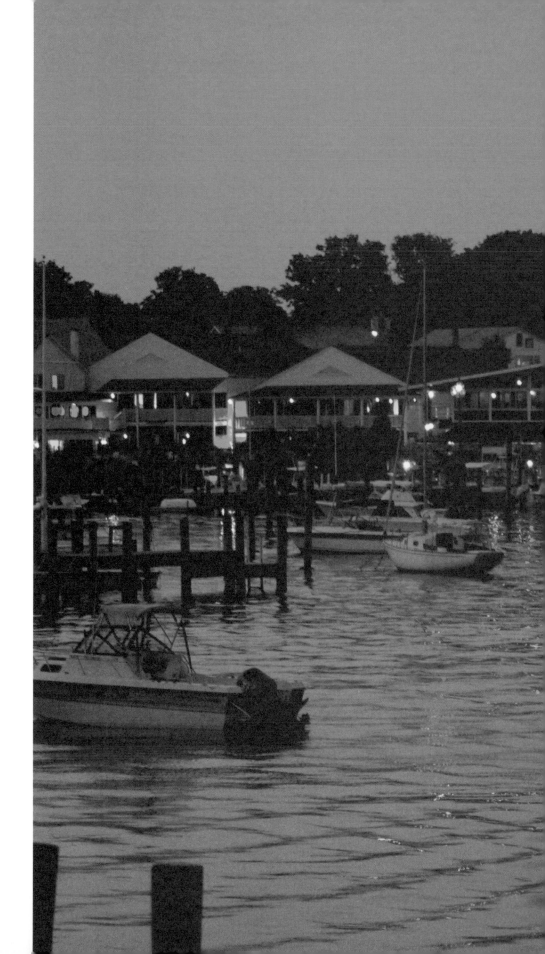

Edgartown

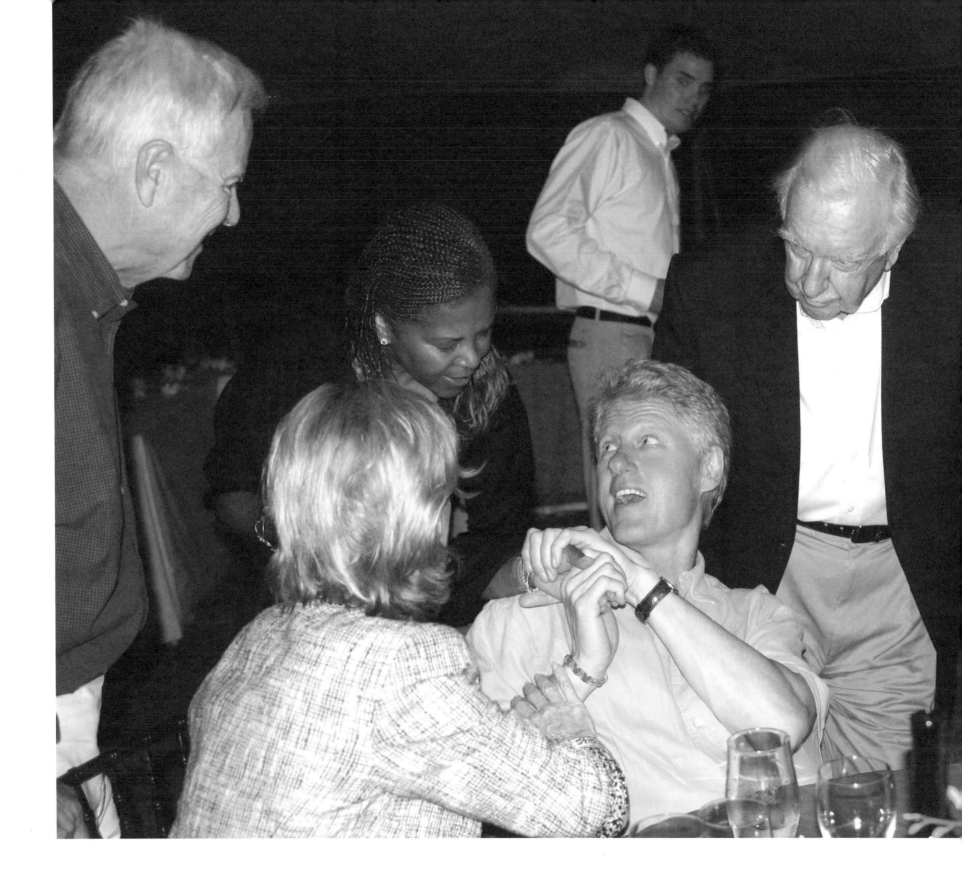

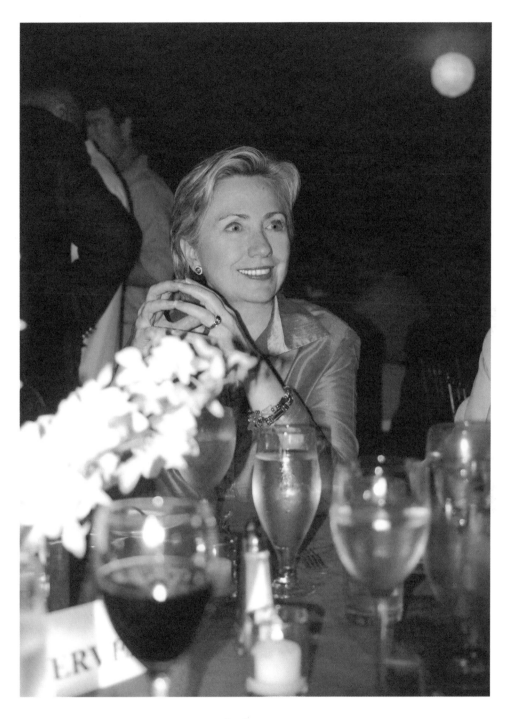

Book party

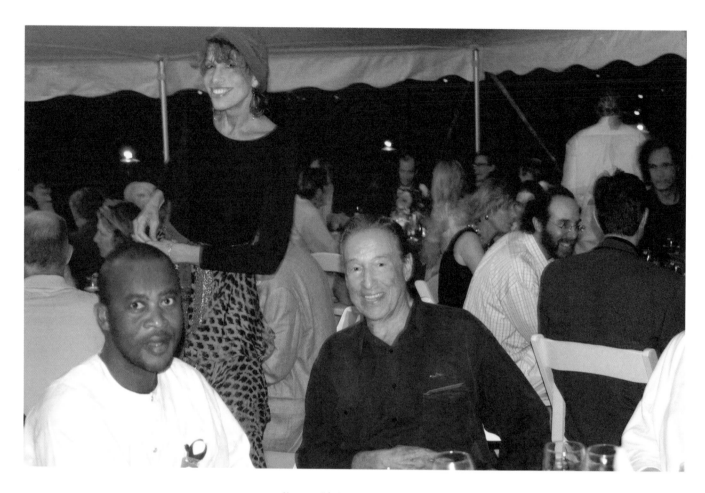

Human Rights Awards dinner

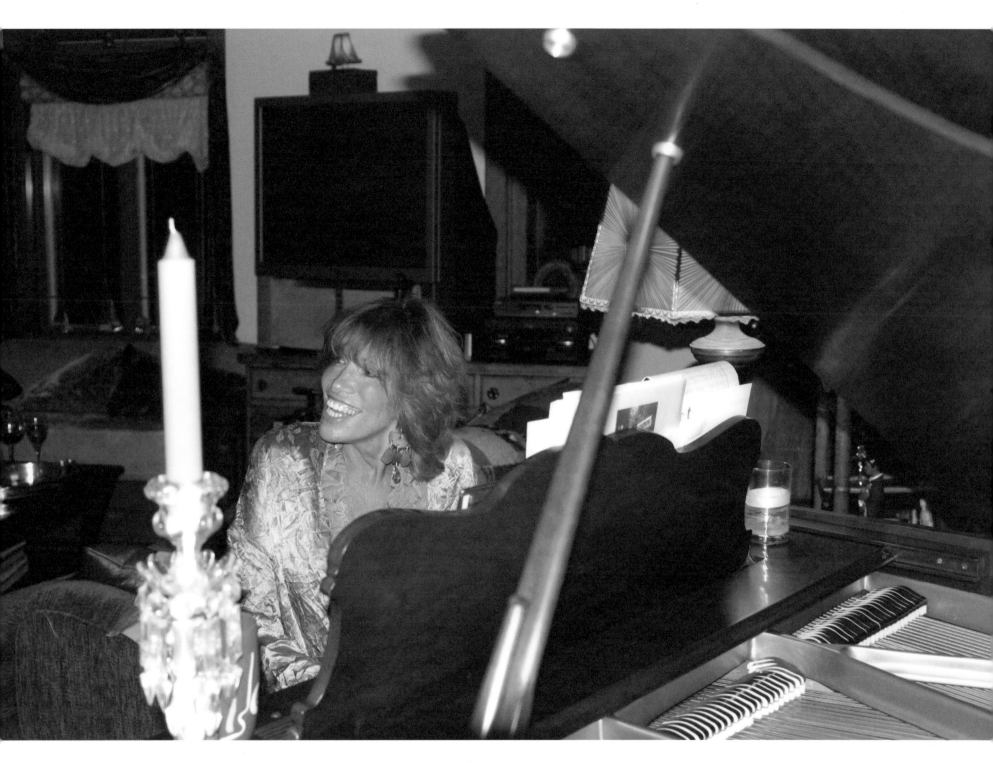

At home

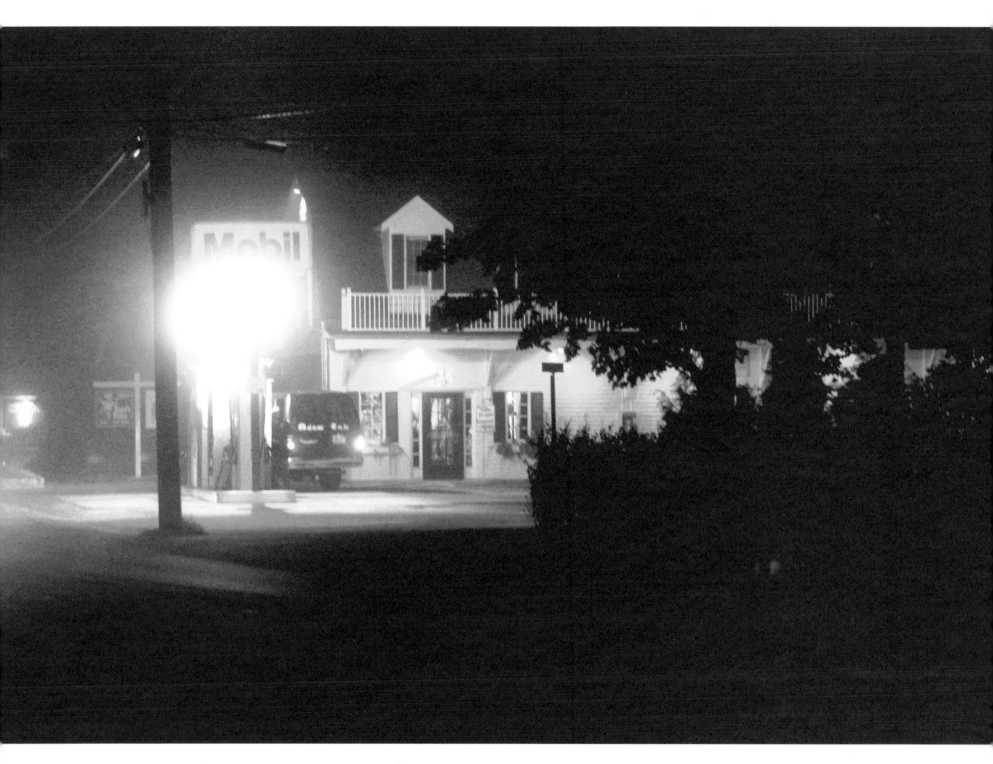

Edgartown

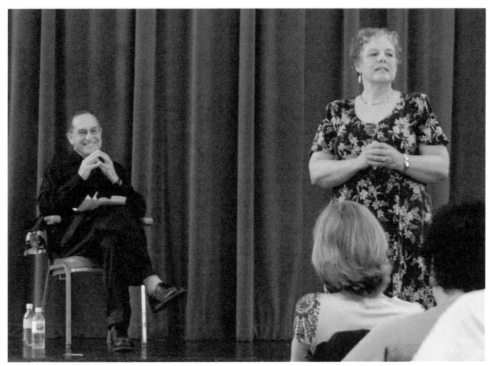

Top: After the party. Bottom: Book event, Katharine Cornell Theatre.

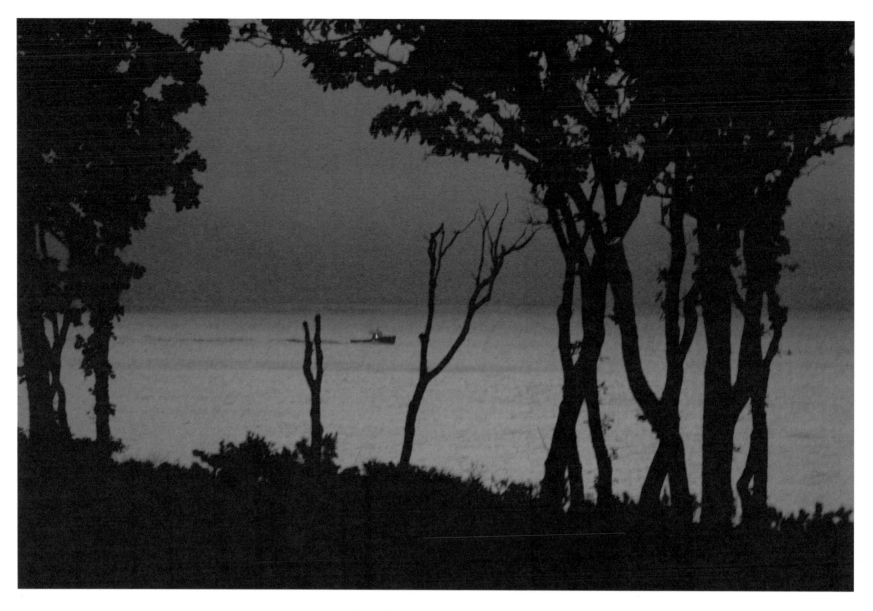

Returning home, Vineyard Sound

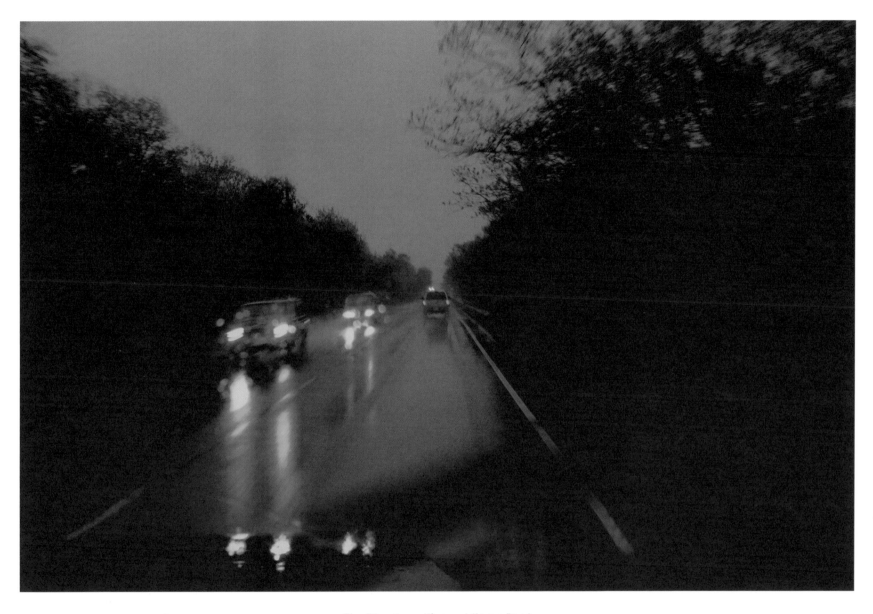

The Edgartown—Vineyard Haven Road

Scrub Oaks at night, North Shore

NOTES

My journey into the romance of Martha's Vineyard began three years ago as an idea for an exhibit at the Carol Craven Gallery in West Tisbury. I wanted to photograph our local pond (officially known as Uncle Seth's Pond) as the Impressionists painted Argenteuil—that is, I wanted viewers to experience the same image as it changed in light, atmosphere, and population—all the incredible variations of nature. I decided to use a digital camera. Well, I shot Seth's Pond under wonderfully varied conditions—some images of which are included in *Vineyard Days, Vineyard Nights*—but my greedy eye could not rest at Seth's Pond alone.

Working for the first time with digital imaging exclusively (save two instamatic "snaps"), I could not hold back. It brought me to the computer and Photoshop, a world utterly unfamiliar to me. Trained as a painter, I've always viewed the technical aspects of photography as alien. While I have learned to cope with technique, it has never been my ally. Oddly, I found that while working with an image on the computer, I was actually getting my hands *into* the imagery—the same sense of "hands on" that working with a paintbrush or a piece of charcoal gives.

My camera of choice, when I started this project, was the Canon EOS D30. About halfway into the project I upgraded to the newer EOS D60, but by the time I finished last September my camera was somewhere between quaint and obsolete! While most of the photographs were quietly shot in leisure, others were shot fleetingly, from a car window, giving the image the same ephemeral sense as a glimpse.

The following notes are more about the image photographed than about the photograph itself:

Page 34
The Art Cliff diner, Vineyard Haven
Open year-round for breakfast, lunch, and dinner. For reasons of its own, it closes early—after lunch—in summer. Perhaps the lines are too long even for them!

Pages 38-39
The dock in Menemsha Basin, Chilmark
According to my friend, Gary Stuber, it belongs to Lyn Murphy, who operates Menemsha Marine. "He is one of a very few, last of the old-timers. He is like a nor'easter on a sunny day; one never knows what to expect!" Does it remind you of *Jaws*?—It should.

Pages 57-61
The Boat Yard, Beach Road
Craftsman and designer Nat Benjamin and his partner, Ross Gannon, founded Gannon and Benjamin Marine Railway in 1980, a boatyard dedicated to the designing and restoration of wooden boats. The day I visited the Annex, I found Benjamin finishing the construction of the *Juno*, a sixty-five foot schooner. Clearly I had something special to photograph—the largest boat built on Martha's Vineyard since the Civil War. Exotic woods, such as angelique, wana, and teak, were harvested from the rain forests of Suriname. There was a sense of calm, an almost spiritual feeling in the air. Touched by the unplastic, handcrafted grace of the *Juno*, I asked if working in wood was "spiritual" for him. His response: "The process is life."

If you like the romance of wooden sailboats I refer you to the book *Wooden Boats* by Michael Ruhlman, which is all about this renowned boatyard.

Pages 62-63
The Big Tree, West Tisbury
The Big Tree across from Humphrys, the Old Historic Tree, the Eisenstadt Tree . . . Everyone knows and has their name for the most famous tree on the Island. Hit by lightning, this centurion oak is but half its former size, but remains breathtakingly majestic. Craggy and dramatic in winter, it becomes as exquisite as lace in spring.

Page 74
Camp Meeting Grounds, Trinity Park, Oak Bluffs
There are many books available on these charming gingerbread cottages, all of which have fanciful names. My favorite story was told to me by Camp Grounds resident John Firestone on front-porch etiquette! Apparently, exactly how you situate your rocker determines how neighbors will regard you. If you are sitting in your rocker facing the street directly you are signifying, "Yes, welcome, drop by!" If you angle your rocker viewing the street obliquely, you are saying, "Tip your hat, yell hello but do not drop in." If, however, you turn your back to the street, not *any* greeting is appreciated. Simple enough, unless you're new to these parts!

Page 78, Top
John's Fish Market, Vineyard Haven
Sandy Healy holding a 7-pound lobster. Owner of John's Fish Market and Sandy's Fish 'n' Chips, she is our daily source of lobster, fresh fish, clams, and soft-shell crab burgers (heaven!). Behind her is a sign that reads "I can only please one person per day. Today is not your day . . . tomorrow's not looking good either!" Ask Bill Styron if John's Fish Market pleases him: "Best raw bar on the Island."

Page 78, Bottom
Main Street, Vineyard Haven
Bunch of Grapes Bookstore and Café Moxie on the left. Turn right and take a short walk to Midnight Farm, Carly Simon and Tamara Weiss's lovely Vineyard emporium.

Page 79
The Aquinnah Shop on the Cliffs, Aquinnah
A Native American family-owned business; Luther Madison and Ann Vanderhoop are members of the Wampanoag Tribe. Cully Vanderhoop at the grill. Hmmm! Lobster eggs?

Page 80
The Aquinnah Shop on the Cliffs, Aquinnah
Looking at the front of this shop, it would be impossible to know it has the most breathtaking view on the Vineyard. Lisa Birnbach, author of *The Official Preppy Handbook*, used to bring her family to the shop to get soft Indian moccasins and enjoy the view, but since "Cousin Luther" started cooking she comes for the excellent fried fish. "Damned good! A diner atmosphere with fantastic views and tablecloths!"

Page 81
The Bite, Basin Road, Menemsha
"I made a U-turn in front of the old red-roofed Coast Guard station, now the Chilmark Police Headquarters, going to the far end of the main road toward the gas station. Larsen's Fish Market has closed hours ago, so my last hope was the Bite, a two-hundred-square-foot gray-shingled kitchen from which the Quinn sisters put forth the best chowder and fried clams on the face of the earth."

Actually, they are the Flynn sisters—not the Quinn sisters—but the quote is from Linda Fairstein's most recent best-seller *The Kills*. While Linda's books usually deal with crimes set in New York City, she always takes her readers "home" to Chilmark and to the Bite, her brief retreat from fictional mayhem.

Pages 82-83
A literary lunch, Vineyard Haven
Bill and Rose Styron at home.

Pages 84-85
Guest cottage at Chip Chop, Tisbury
Chip Chop must surely be one of the most legendary, famous, and breathtakingly beautiful homes on the Island. Built by the equally legendary Katharine Cornell, it is now the gracious home of Mike Nichols and Diane Sawyer. I think they call it heaven.

Pages 86-87
On board the *Wyntje*
Walter Cronkite on board his ketch the *Wyntje*. Walter is a keen sailor. One need only to watch him maneuver the Edgartown Harbor with all those boats at anchor, under sail, with no auxiliary motor running, to see his expert and effortless skills. And we thought he was *just* the most trusted man in America!

Page 90, Top
Watercolorist with handbag
Helen Mirren, a great actress, a great broad, now a great Dame, was a Vineyard houseguest. The English have a style all their own . . . who else but an English Lady would hold their pocketbook while doing a watercolor. Precisely!

Page 90, Bottom
The luncheon host
This luncheon host is Sir Evelyn de Rothschild on the terrace of his West Chop vacation house. Married to the former Lynn Forester, a long-time summer visitor to the Vineyard, he has happily joined our relaxed lifestyle.

Page 91
Waiting for the party to begin
Why, you ask? Left to right: Bill Rollnick, Buzz, Paul Theroux, and Dame Helen Mirren, apparently with nothing to do while everyone else prepared for the party that night—not that I'm complaining—I apparently also had nothing else to do but take this delicious group photo.

Page 99
Noon dip
Susan St. James and Dick Ebersol with their sons, Willie, Charlie, Teddy, on a day-sail to the Elizabeth Islands.

Page 117
Possible Dreams Auction, Edgartown
From left: Rosalee and David McCullough, Mary and Mike Wallace, and Susan Bailey. A celebrity-packed audience donates, bids, and keeps the energy high at the annual fundraiser for the Martha's Vineyard Community Services. The auction raises more than $500,000 each year to serve the Island's winter population. David McCullough donated a personal historical tour of the John Adams home in Quincy, Massachusetts. Mike and Mary donated themselves for dinner.

Page 118
Possible Dreams Auction, Edgartown
Left to right: Jules Feiffer, Carly Simon serenading Art Buchwald

Page 119
Possible Dreams Auction, Edgartown
The grand auctioneer and energy behind the auction's success, Art Buchwald. He spends the year digging up ideas that cannot be bought. Boy does he! Falconing with John Kennedy, Jr., a walk on the beach with James Taylor, luncheon at Chip Chop with Diane Sawyer and Mike Nichols, a private reading by Bill and Rose Styron–on and on–magical, delicious moments with lobstermen, bird watchers, celebrities, historians, artists, musicians, the heart of the Island giving back to the community it loves so dearly.

Page 125
Cocktails on board the *KelDi*, Edgartown
Left to right: Richard Foster and Robert Day

Page 133
Alfresco dining, Menemsha
This gentle man is enjoying one of the great Vineyard delights, a grand sunset picnic on the docks at Menemsha. He went to either Larson's or Poole's Fish Market for his freshly steamed lobster. If you live up-Island you probably belong to one of two camps–those who favor Larson's and those who favor Poole's. Passions run high and I advise you to not get in the middle or be politic. Instead take sides–adorn your car with a bumper sticker and enjoy the results–but back to our gentleman and to the alfresco dining experience he is enjoying. A romantic sunset at Menemsha is enjoyed by residents and tourists alike. The fishing boats are back, and the restaurants and markets are offering lobster and the catch of the day. Remember, Menemsha is dry so bring your own Chardonnay, pull up a crate, and dine among the glorious mixture of lobster traps, anchor chains, and golden light.

Page 154
Book party, Edgartown
There are lots of book parties and book signings on the Island. The Vineyard loves authors. But this book party, hosted by Frank and Carol Biondi, was for Hillary Clinton who had spent the day at Bunch of Grapes signing thousands of books! Left to right: Terry Jastrow, Anne Archer, and Vernon Jordan.

Page 155
Human Rights Awards dinner, Edgartown
The Reebok Human Rights Awards dinner was at the home of Jim and Susan Swartz.

Pages 160-161
Book party
Hillary Clinton's book party at Carol and Frank Biondi's home in Edgartown. At the tables, from left to right: Dick and Nancy Riordan, Eileen Norton, Bill Clinton, Walter Cronkite, Eli Broad, and the radiant Hillary Clinton, fingers still intact after an incredibly successful book signing in honor of her best-seller *Living History*.

Page 162
Human Rights Awards dinner, Edgartown
The Reebok Human Rights Awards dinner at the home of Jim and Susan Swartz. Left to right: Liberian political leader and human rights activist Samuel Kofi Woods, Carly Simon, and Mike Wallace.

Page 163
At home
Carly Simon at home performing *You're So Vain* to Dick Ebersol and friends. Dick bid $50,000 at the Possible Dreams Auction (which raises needed funding for the community's winter services) to eat peanut-butter sandwiches and find out Carly Simon's secret: The name of her "vain" paramour! But all who heard his name were sworn to secrecy. Not even Artie Buchwald could pry the answer from the tight-lipped six!

Page 165, Top
After the party
Sheila Donnelly Theroux, as my father used to say, "just resting her eyes," after a party but before the conversations ended.

Page 165, Bottom
Book event, Katharine Cornell Theatre
The learned and entertaining Alan Dershowitz being introduced by Bunch of Grapes events coordinator, Ann Bassett, at a lecture on his most recent book, *America Declares Independence*. The Katharine Cornell Theatre in Vineyard Haven was packed with interested and curious people.

West Tisbury

Text and photographs copyright © 2004 Nancy Ellison
Essay *Martha's Vineyard* by Paul Theroux
Author photograph copyright © 2004 Bill Rollnick
Project editor: Sandy Gilbert
Production manager: Kim Tyner

Published in 2004 by
Stewart, Tabori & Chang
115 West 18th Street
New York, NY 10011

Canadian Distribution:
Canadian Manda Group
One Atlantic Ave; Suite 105
Toronto, Ontario M6K 3E77
Canada

Library of Congress Cataloging-in-Publication Data is on
file with The Library of Congress.

ISBN: 1–58479–378–3

Design by Alexandra Maldonado

The text of this book was composed in Trade Gothic.

Printed in Thailand

10 9 8 7 6 5 4 3 2

Stewart, Tabori & Chang is a subsidiary of

LA MARTINIÈRE
GROUPE

ACKNOWLEDGMENTS

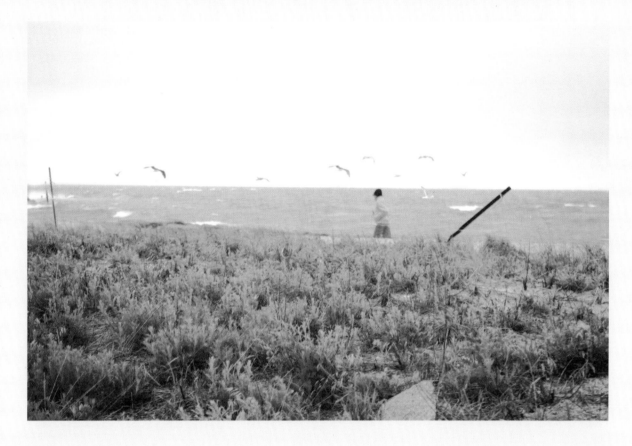

To the citizens of Martha's Vineyard who, while they have done absolutely nothing in the presentation of *Vineyard Days, Vineyard Nights*, have in fact done absolutely everything wonderful in the presentation of a perfect Vineyard summer: including Ralph Friedman, who brings us his lovely ripened tomatoes while ours are still green on the vine; Richard Toole, Martha's Vineyard Commissioner and a fine member of the "Conservation Police;" Jamie Hamlin; Christian Thornton; Andrew Flake; Walter Smith; Brigit Towbin; Olga Hirshhorn; Joe Doebler, who e-mails us his photos of our lovely Pilot Hill Farm during winter; Mary and her staff at Groomingdale's; to any electrician willing to return a phone call and to all septic-tank cleaners who (for obvious reasons!) keep our sweet Island sweet-smelling. Thank you.

My genuine thanks to those Vineyarders and summer people who in one way or another made this book possible: Carol Craven, Robby Bick, Nat Benjamin, Yvette Rigaud, Lynne Irons, Laura Roosevelt, Tamara Weiss and Gary Stuber, Joan Merry, Deborah Ratcliff, Peter Van Tassel, Linda Fairstein, Lisa Birnbach, Kelly and Robert Day, Diane Sawyer and Mike Nichols, Bill and Rose Styron, John Firestone, and to those unknown but lovely people I photographed.

To the wonderful creative team at Stewart, Tabori & Chang whose creativity, energy, and diligence are what holds *Vineyard Days, Vineyard Nights* together: my friend and editor, Sandy Gilbert; publisher Leslie Stoker; art director Galen Smith; and production manager Kim Tyner. To copyeditor Alessandra Bocco, who fine-tuned the text, and to the book's talented designer, Alexandra Maldonado. And to Angela Titolo, I could not have done this book without her.

And finally, to wonderful, brilliant Paul Theroux. Thank you for being part of *Vineyard Days, Vineyard Nights*.

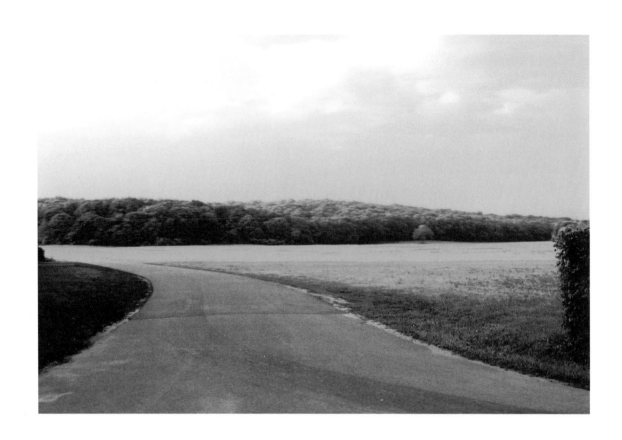